Introduction

Images from nature are a wonderful source of inspiration from artists—and those shown in this book are no exception. Flowers, butterflies, birds, and fish are excellent subjects but can be tricky if you are unsure of your skill level. Coloring in is a very good way to practice your control of line—and the beautiful image opposite the line artwork shows exactly where to place your colors.

The plates in this book are drawn from a number of historical sources of natural history painting. The flowers come from *Choix des Plus Belles Fleurs* (Choice of the Most Beautiful Flowers) by Pierre-Joseph Redouté, published in 1827 and *L'llustration Horticole*, a nineteenth-century Belgian journal illustrated by some of the finest botanical artists of the day. The fish and butterflies are from *The Naturalist's Library* edited by the Scottish naturalist Sir William Jardine and illustrated by William Lazars, his brother-in-law. The birds come from John James Audubon's *Birds of America* (1840–44) and *A History of the Birds of Europe* (1871) by H. E. Dresser.

You will probably find that colored pencils are the easiest tools to use here, blending them to achieve a vibrant finish, and following the natural direction of the subject's textures, working along the lines of the leaves and petals. Alternatively, try watercolor pencils to which you can add water to achieve a smooth wash of vivid color. Be very careful to limit the amount of water you use to avoid over-wetting the paper and allowing it to buckle.

Key: *List of plates*

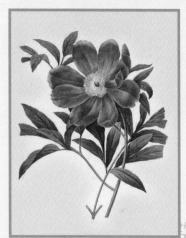

1 Common peony
(Paeonia officinalis)

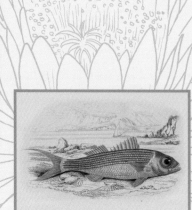

2 Green-backed purple
gallinule
(Porphyrio smaragdonotus)

3 Ruby-coloured Etelis
(Etelis carbunculus)

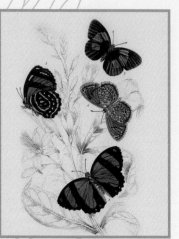

4 1 & 2 *Catagrama
condomanus*
3 & 4 *C. pyramus*

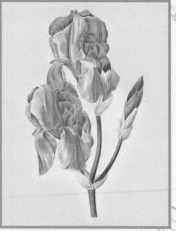

5 Dalmation iris
(Iris pallida)

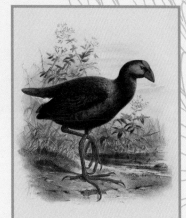

6 Eastern bluebird
(Sialia sialis)

7 Common Perch
(Genus perca)

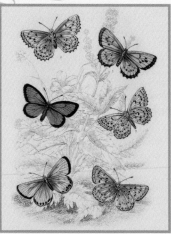

8 1 *Polyommatus arion*
2 *P. alcon*
3 *P. corydon*

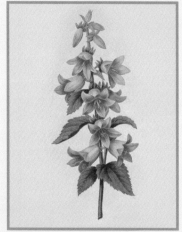

9 Nettle-leaved bellflower
(Campanula trachelium)

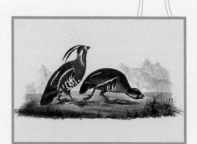

10 Mountain quail
(Oreortyx pictus)

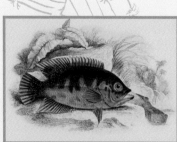

11 Red-spotted Cycla
(Cychla rubro-ocellata)

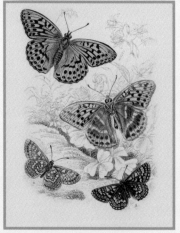

12 1 *Argynnis paphia*
2 *Melitaea cinxia*

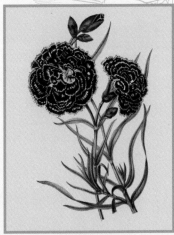

13 Sweet William
(Dianthus albo-nigricans)

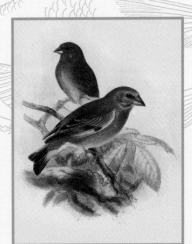

14 Greenfinch
(Carduelis chloris)

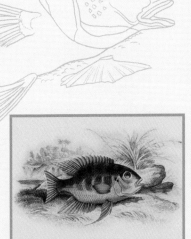

15 Cychla-like Centrarchus
(Centrarchus cychla)

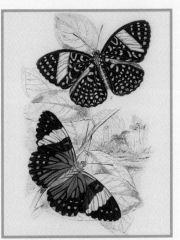

16 1 *Peridromia arethusa*
2 *P. amphinome*

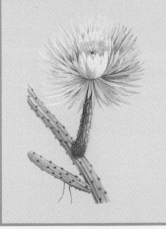

17 Night-blooming cereus
(Cactus grandiflorus)

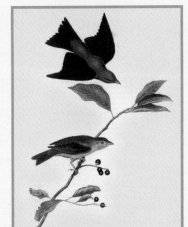

18 Scarlet tanager
(Piranga olivacea)

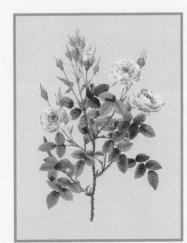

19 Pompon rose
(Rosa pomponia)

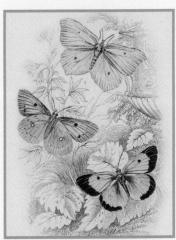

20 1 *Gonepteryx rhamni*
2 *Colias edusa*

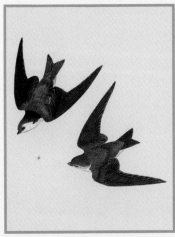

21 Violet-green swallow
(Tachycineta thalassina)

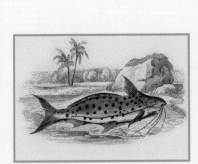

22 Black-spotted Green
Pimelodus
(Pimelodus insignis)

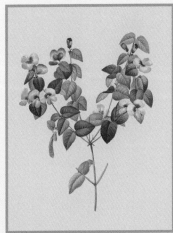

23 Flat-pea
(Platylobium)

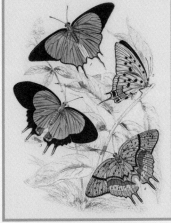

24 1 & 2 *Polyommatus*
Marsyas 3 & 4 *P. endymion*

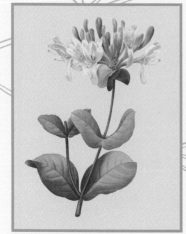

25 Honeysuckle
(Lonicera)

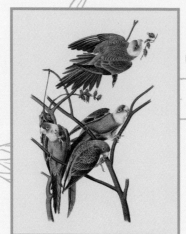

26 Carolina parrot or parakeet
(Conuropsis carolinensis)

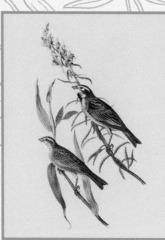

27 Dickcissel
(Spiza americana)

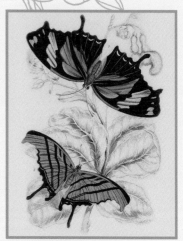

28 1 *Marius thetis*
2 *Fabius hippona*

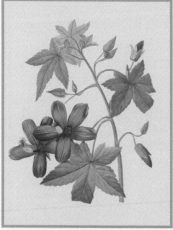

29 Tree mallow
(Lavatera phoenicea)

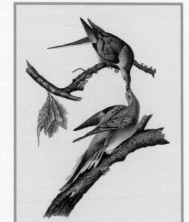

30 Passenger pigeon
(Ectopistes migratorius)

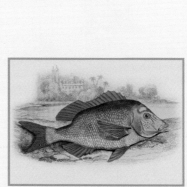

31 Edible Lethrynus
(Lethrynus esculentus)

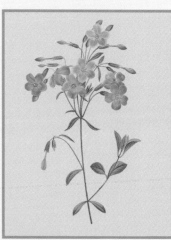

32 Phlox
(Phlox reptans)

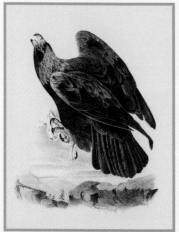

33 Golden eagle
(Aquila chrysaetos)

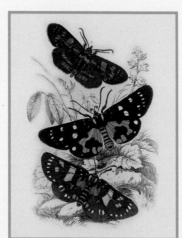

34 1 *Agarista picta*
2 *Eusemia lectrix*
3 *E. maculatrix*

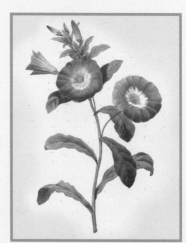

35 Dwarf morning glory
(Convolvulus tricolor)

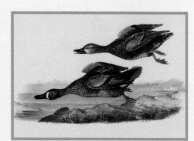

36 Blue-winged teal
(Anas discors)

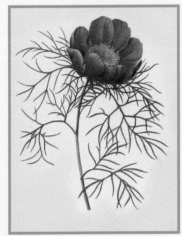

37 Fern-leaf peony
(Paeonia tenuifolia)

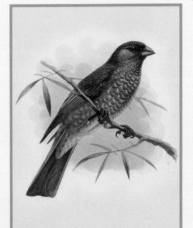

38 Caucasian great rosefinch
(Carpodacus rubicilla)

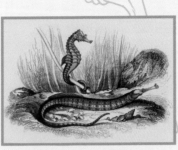

39 Equorcal Pipe Fish
(Acestra aequorea) and
Short-nosed Seahorse
*(Hippocampus
brevirostris)*

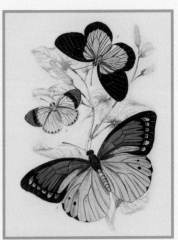

40 1 *Pieris belisama*
2 *Anthocharis danai*
3 *Iphias leucippe*

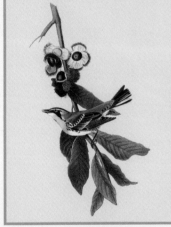

41 Yellow-throated warbler
(Setophaga dominica)

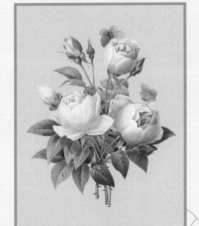

42 Bouquet of roses

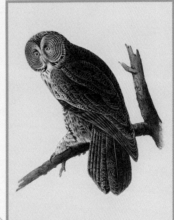

43 Great gray owl
(Strix nebulosa)

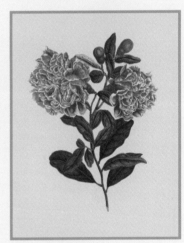

44 Flowering
*(pomegranate Punica
granatum var. legrelliae)*

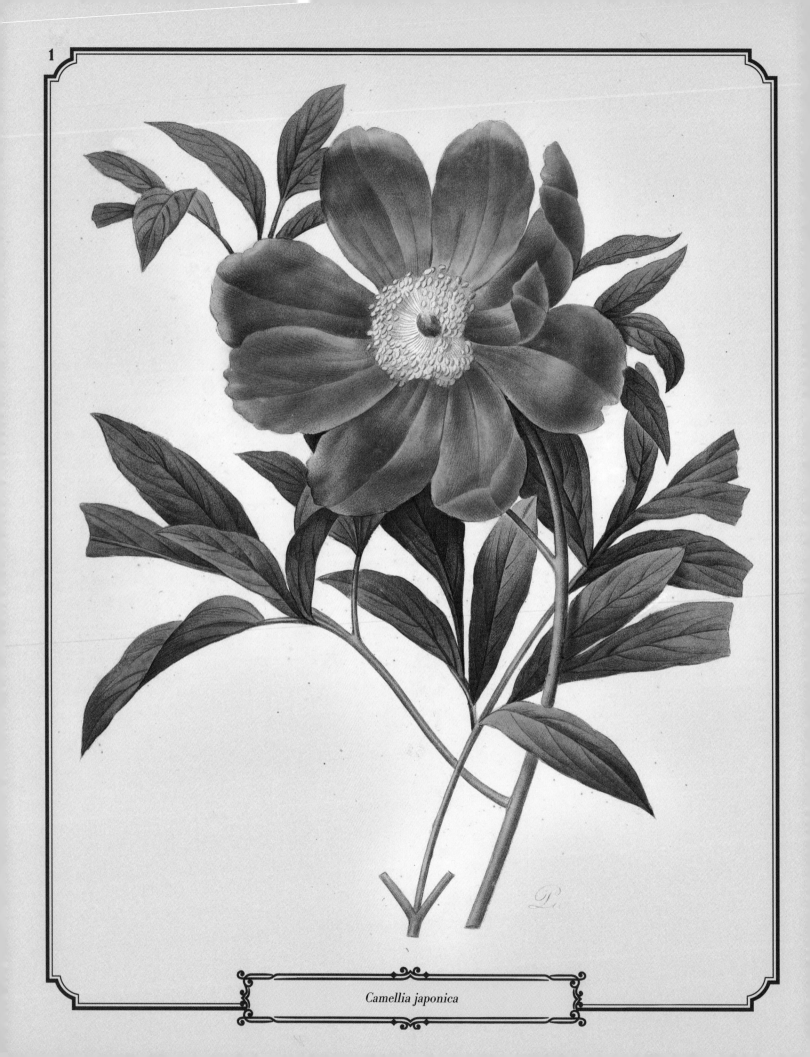

Camellia japonica

Beautiful Nature

COLORING BOOK

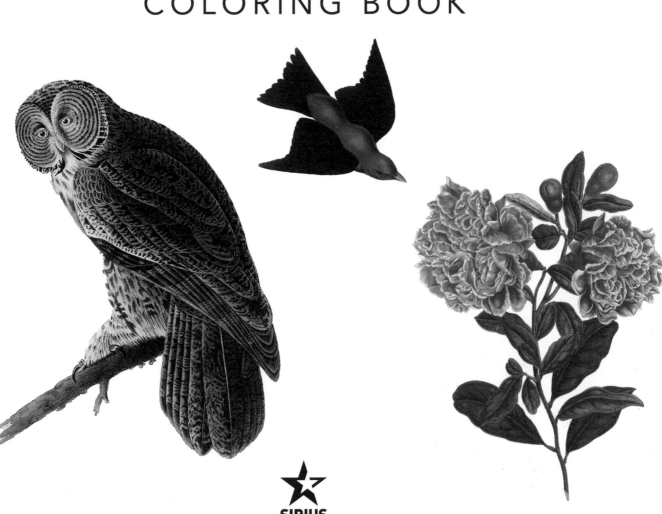

SIRIUS

This edition published in 2022 by Sirius Publishing, a division of
Arcturus Publishing Limited,
26/27 Bickels Yard, 151–153 Bermondsey Street,
London SE1 3HA

ISBN: 978-1-3988-2110-1
CH010866NT
Supplier 29, Date 0422, PI 00001848

Printed in China

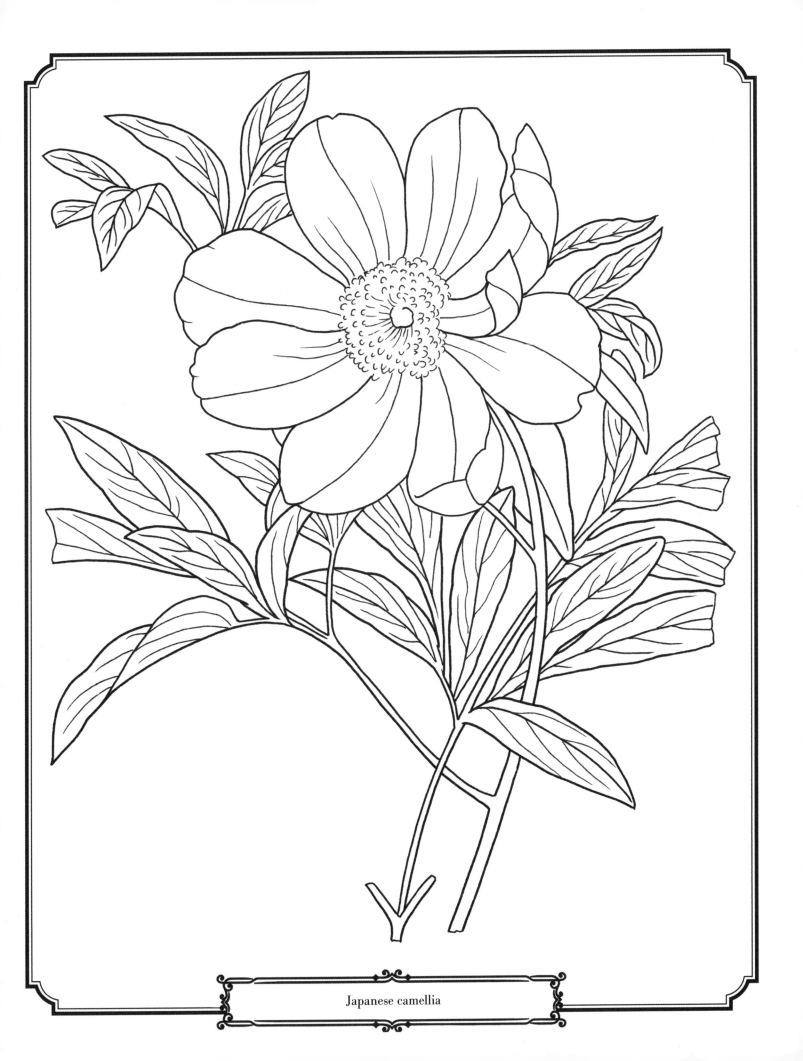

Japanese camellia

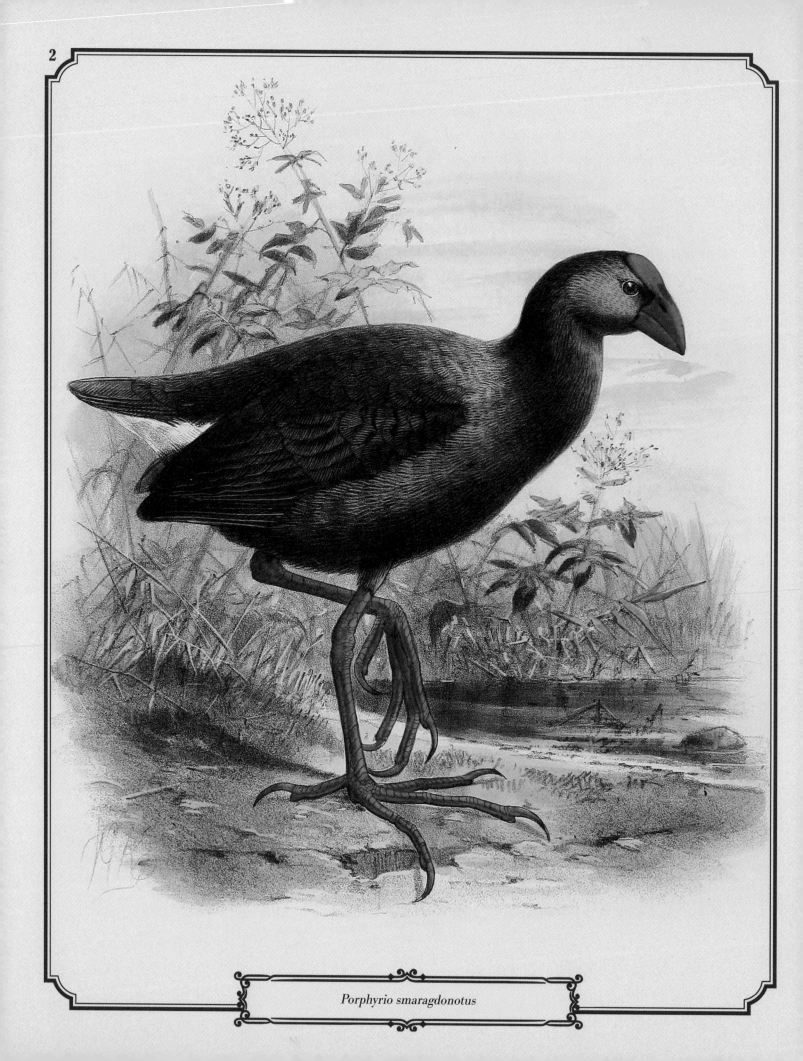

Porphyrio smaragdonotus

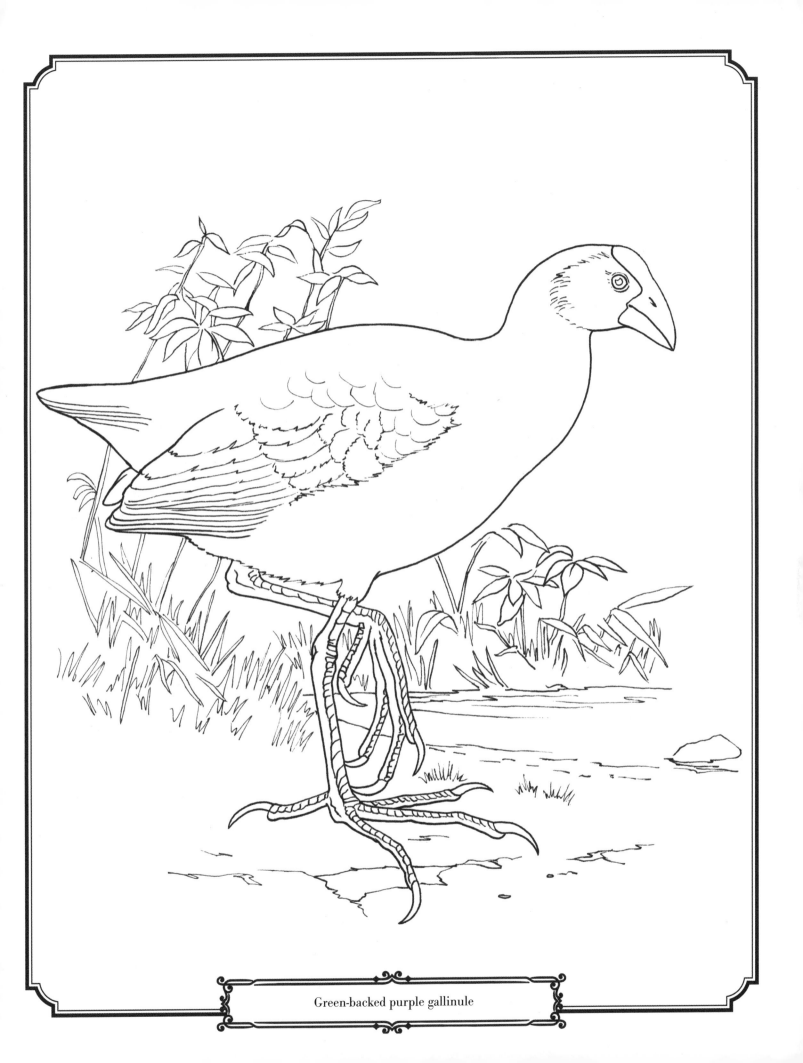

Green-backed purple gallinule

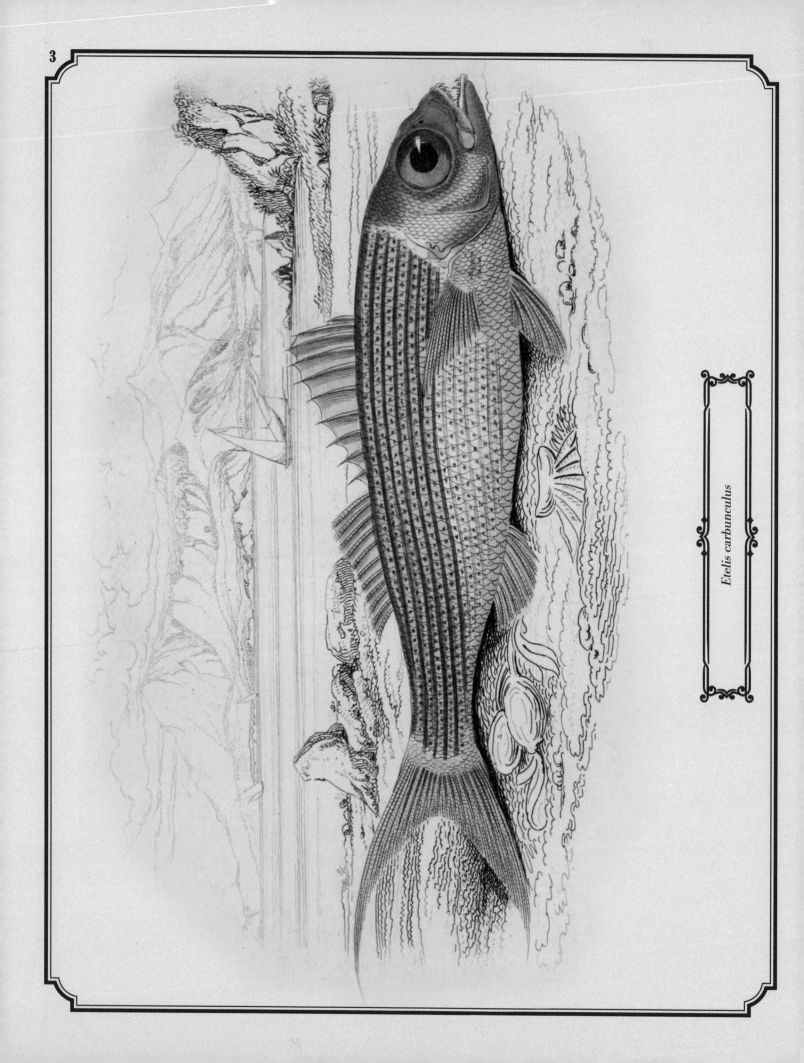

Etelis carbunculus

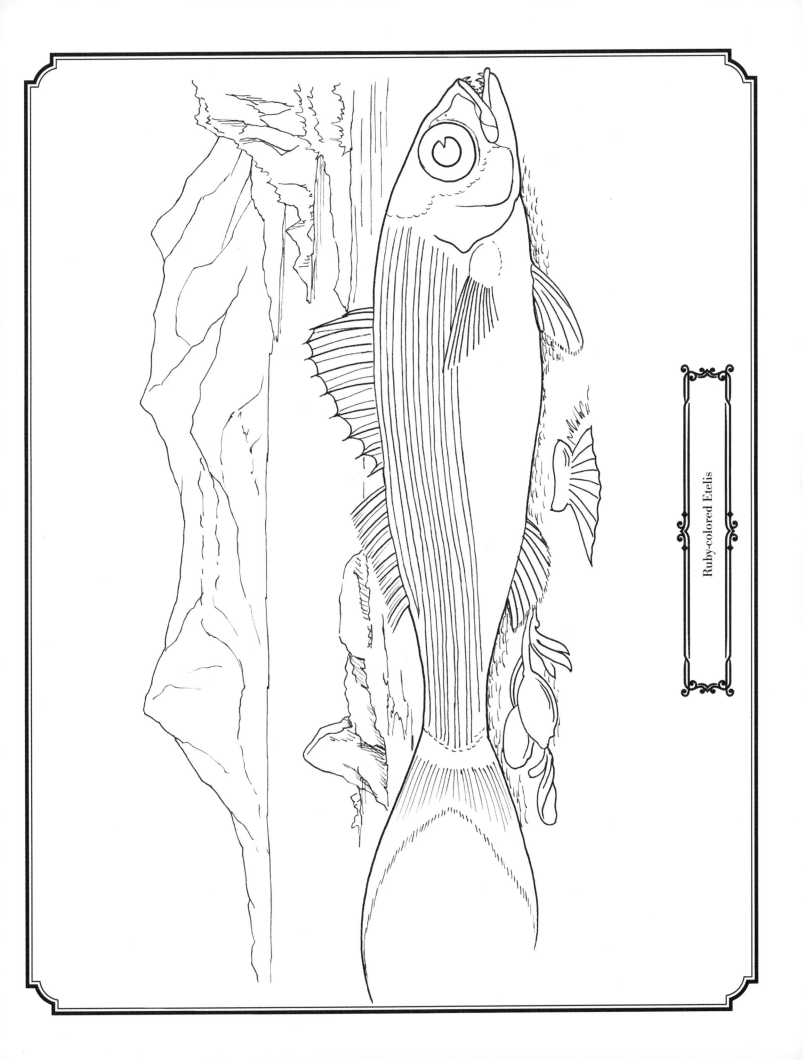

Ruby-colored Etelis

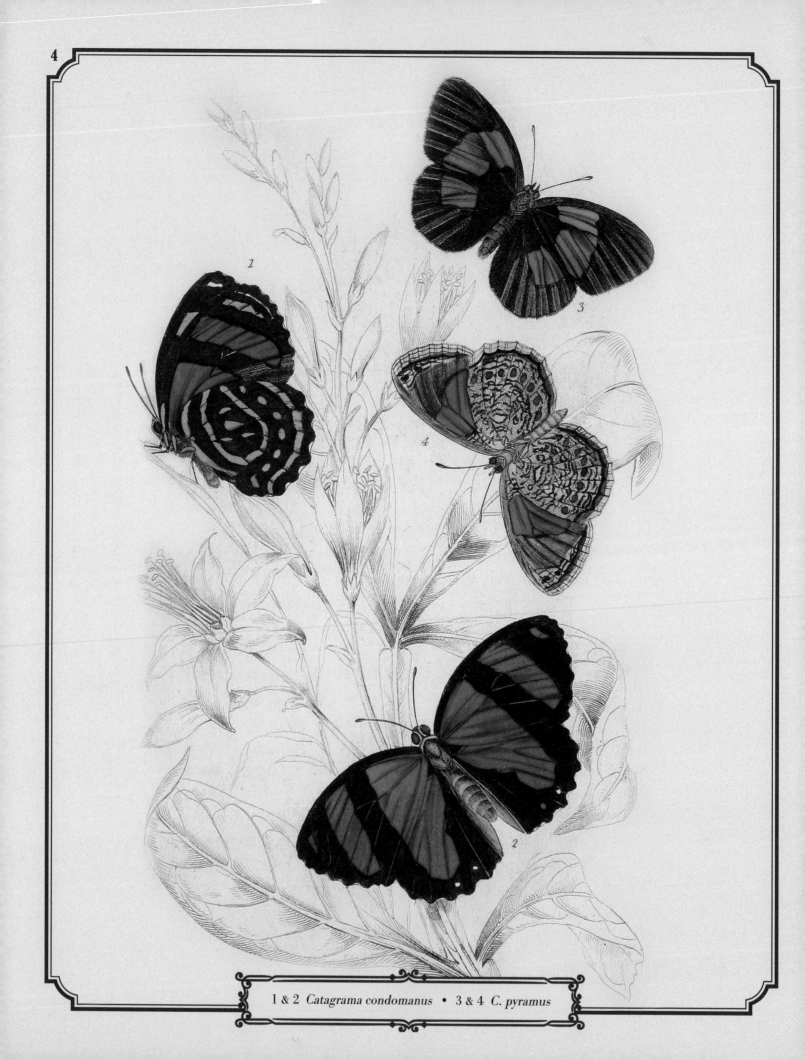

1 & 2 *Catagrama condomanus* • 3 & 4 *C. pyramus*

1 & 2 *Catagrama condomanus* • 3 & 4 *C. pyramus*

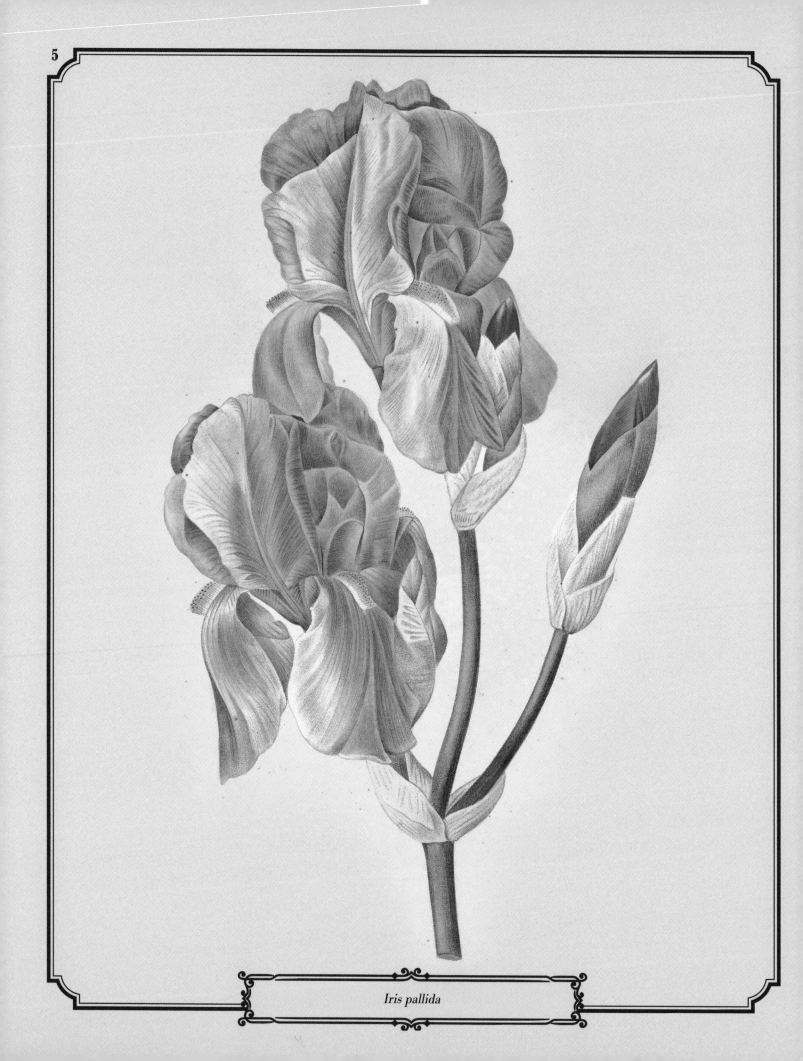

Iris pallida

Dalmation iris

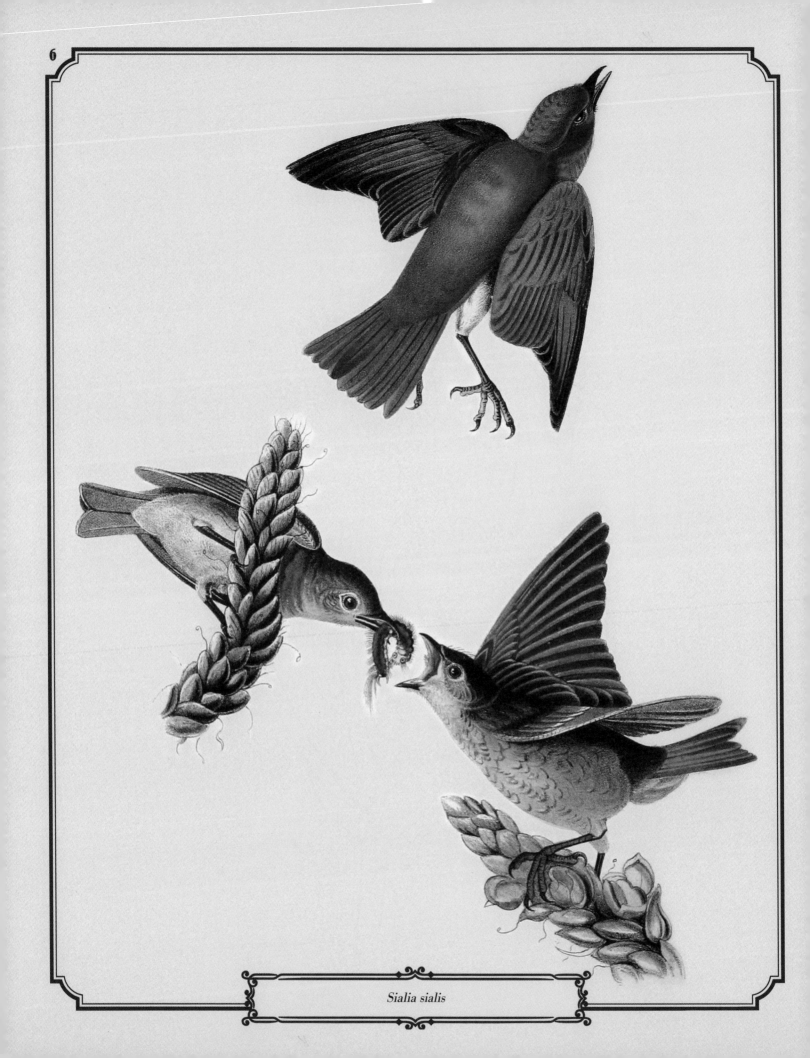

Sialia sialis

Eastern bluebird

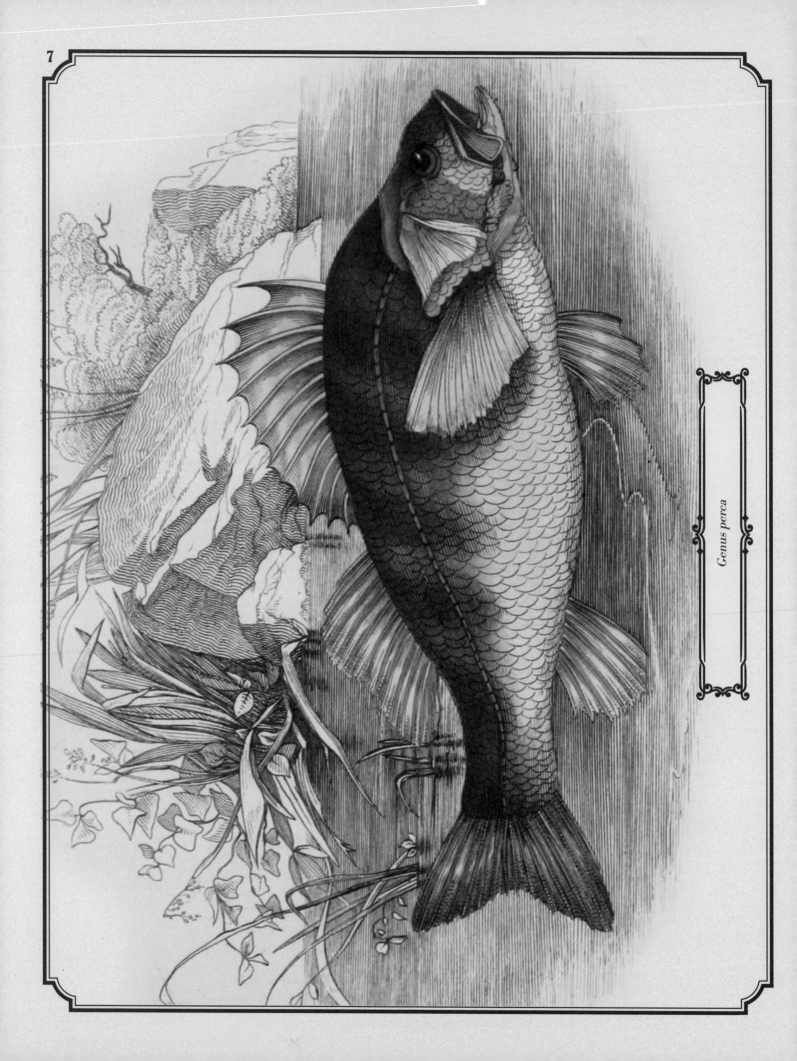

Genus perca

Common Perch

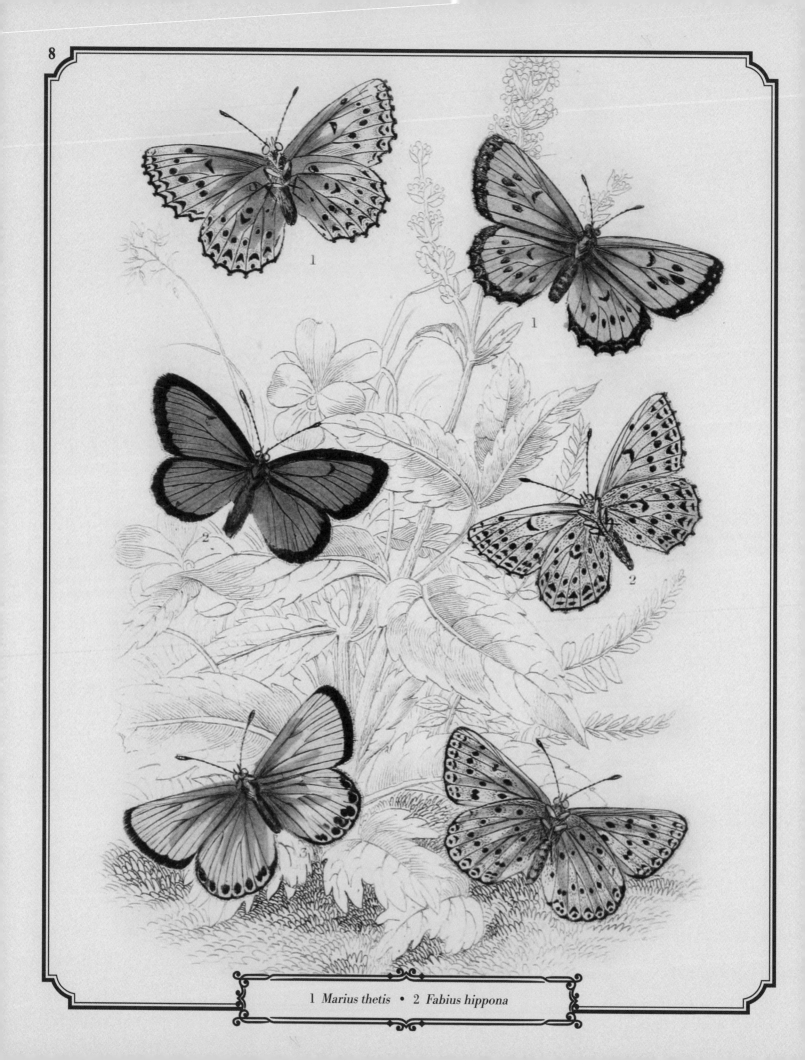

1 *Marius thetis* • 2 *Fabius hippona*

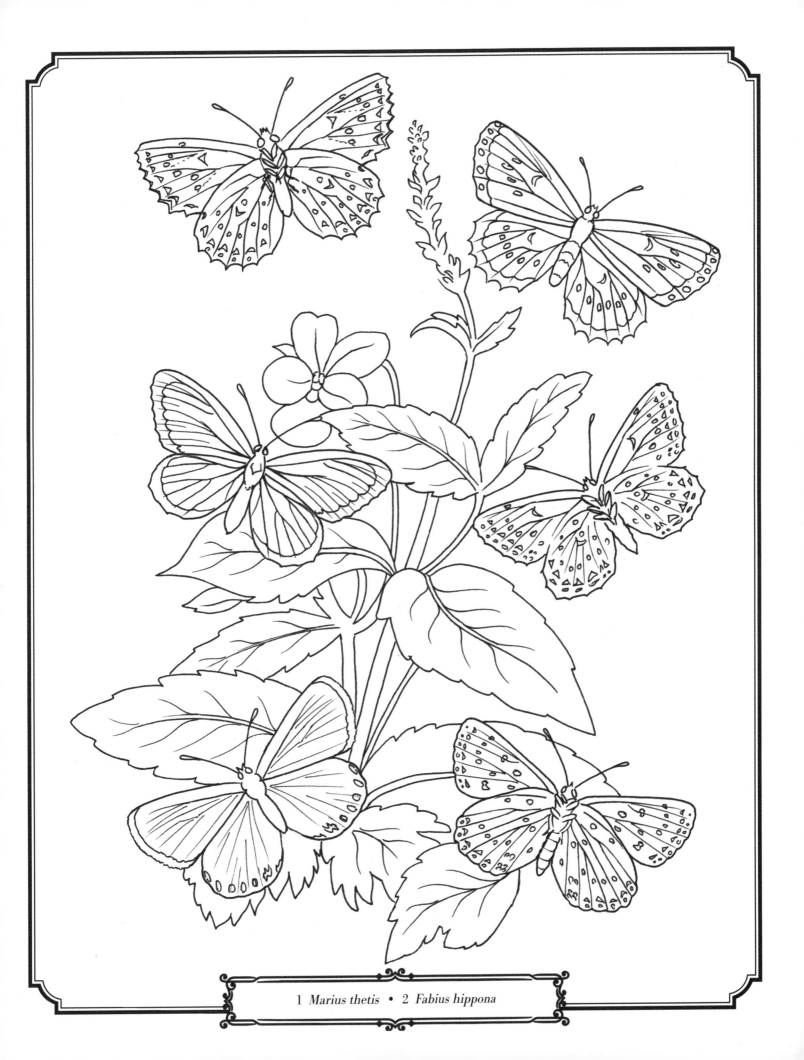

1 *Marius thetis* • 2 *Fabius hippona*

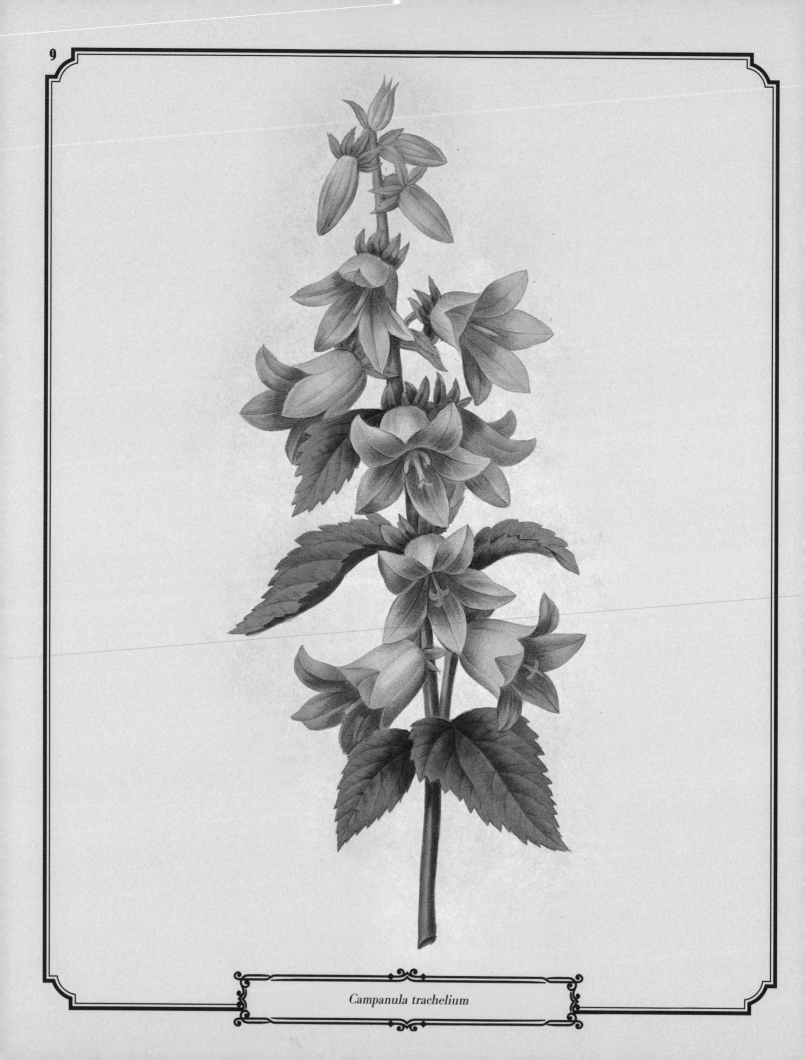

Campanula trachelium

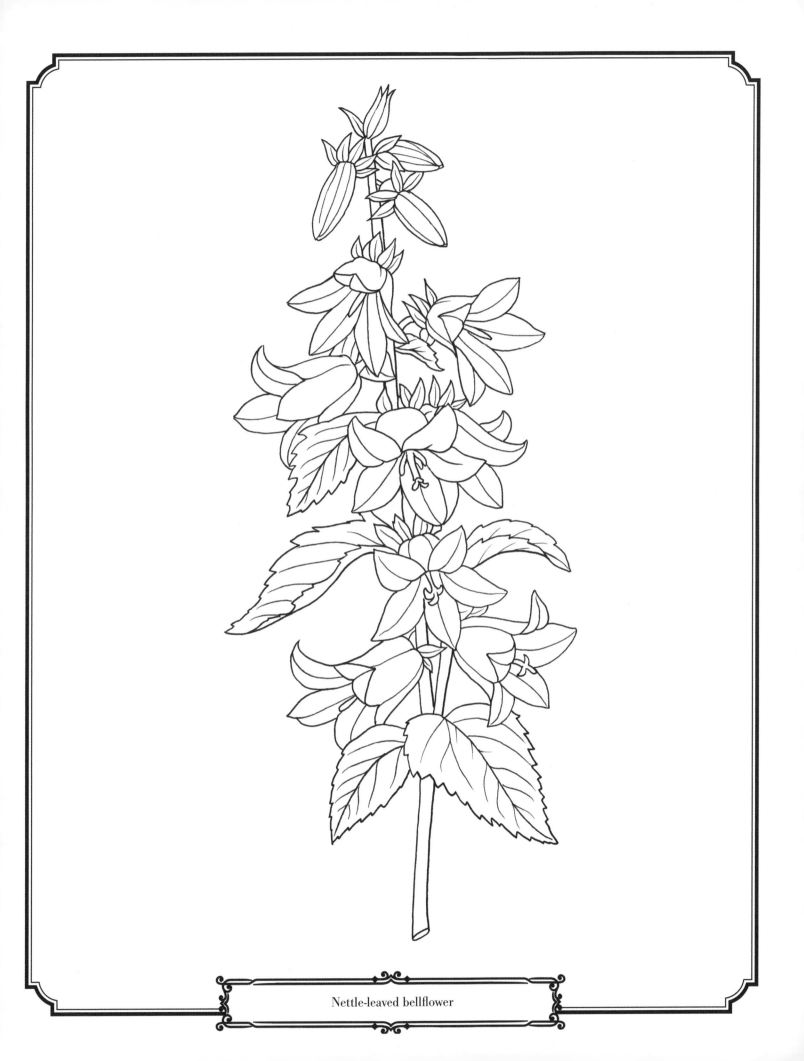

Nettle-leaved bellflower

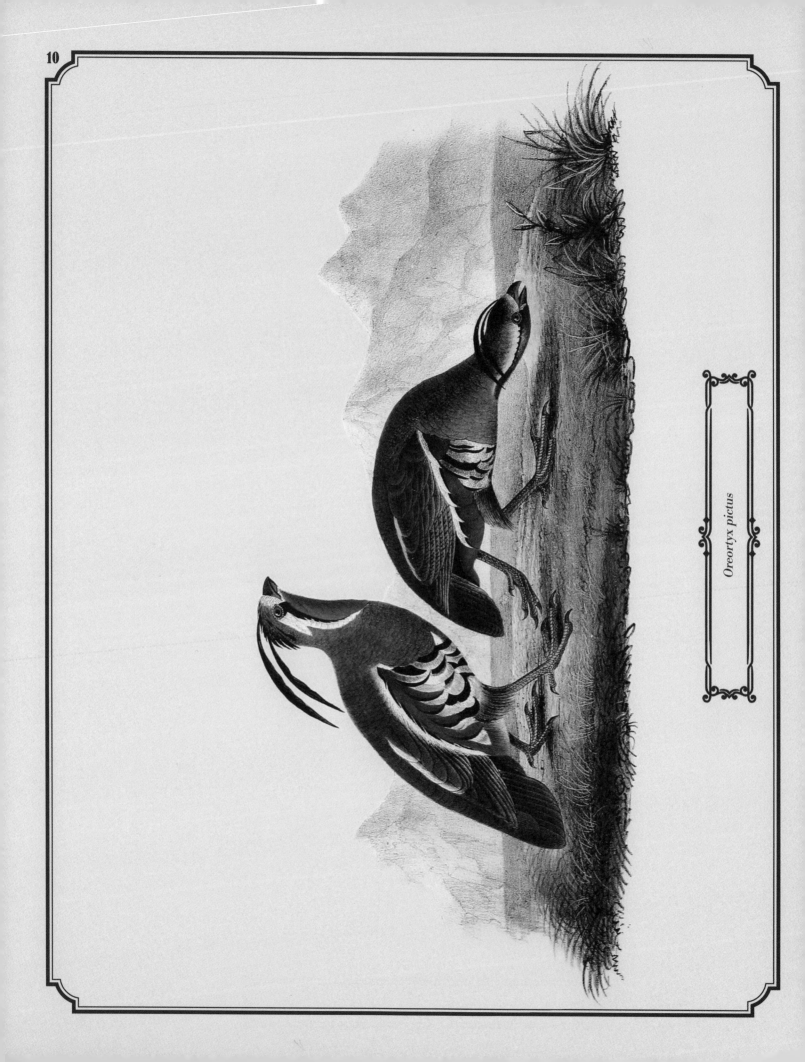

Oreortyx pictus

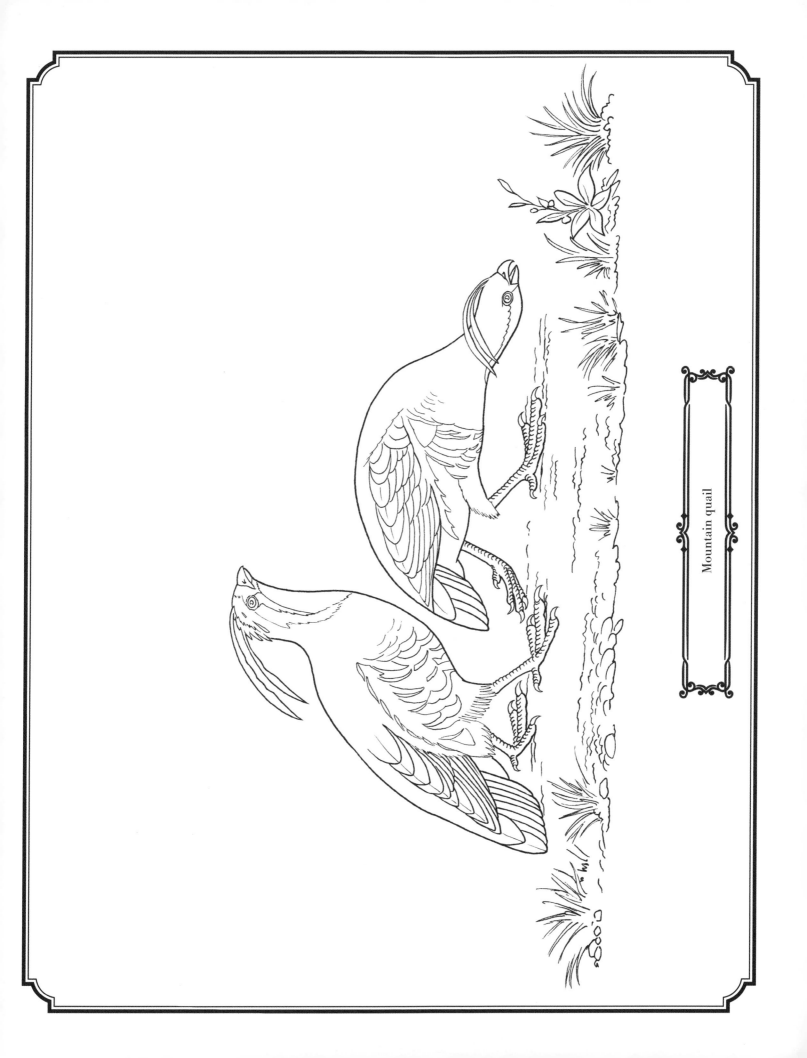

Mountain quail

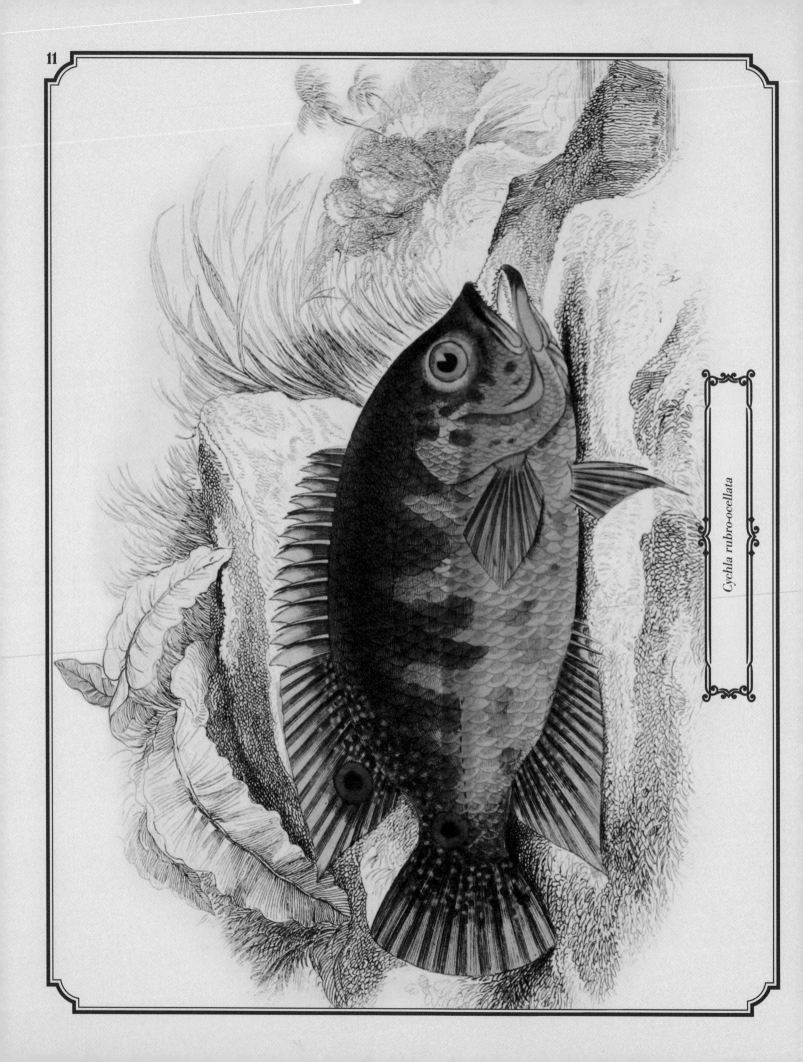

Cychla rubro-ocellata

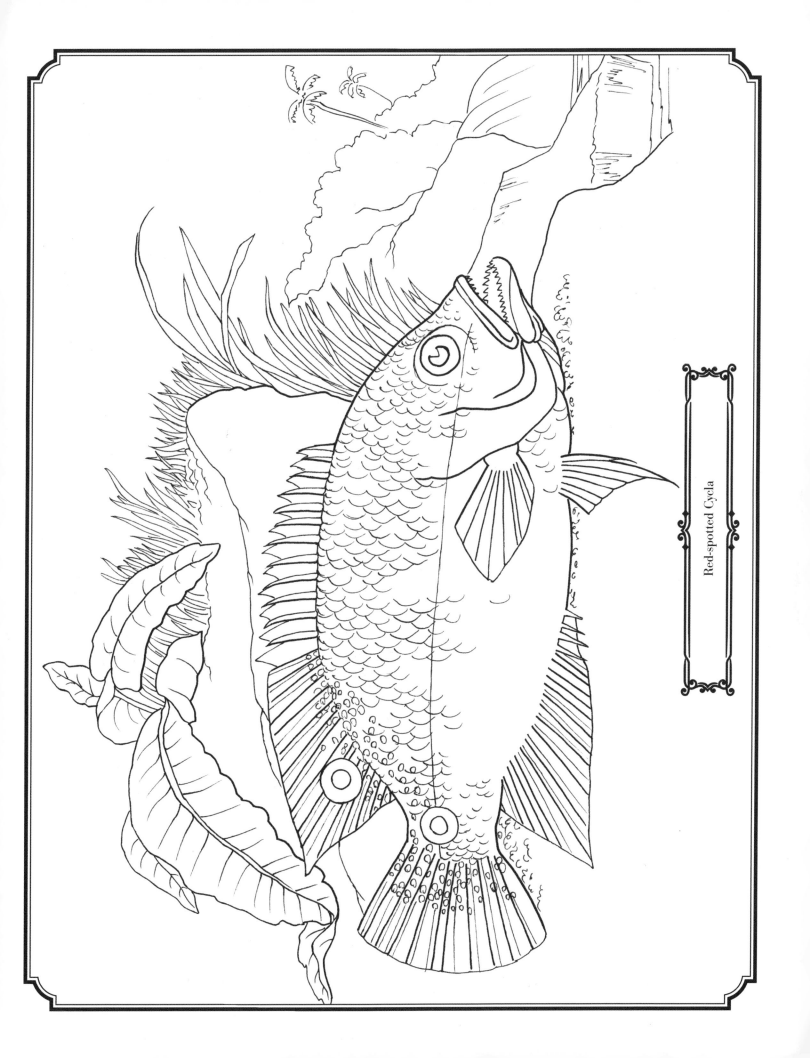

Red-spotted Cycla

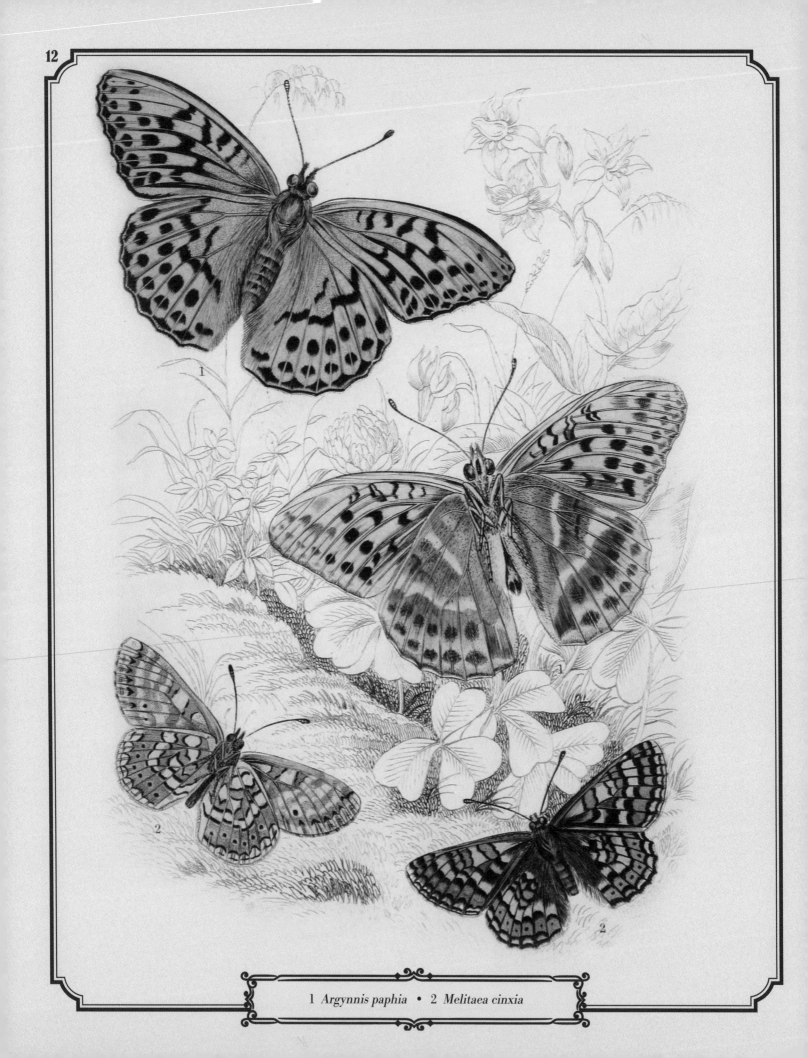

1 *Argynnis paphia* • 2 *Melitaea cinxia*

1 *Argynnis paphia* • 2 *Melitaea cinxia*

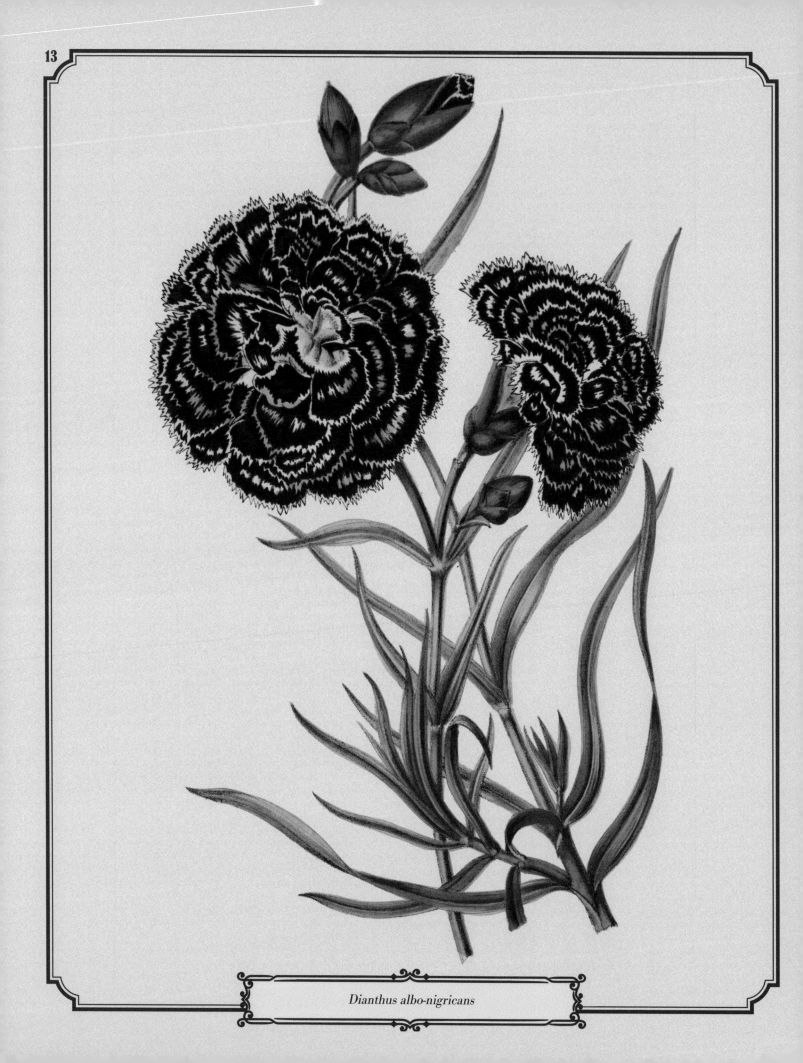

Dianthus albo-nigricans

Sweet William

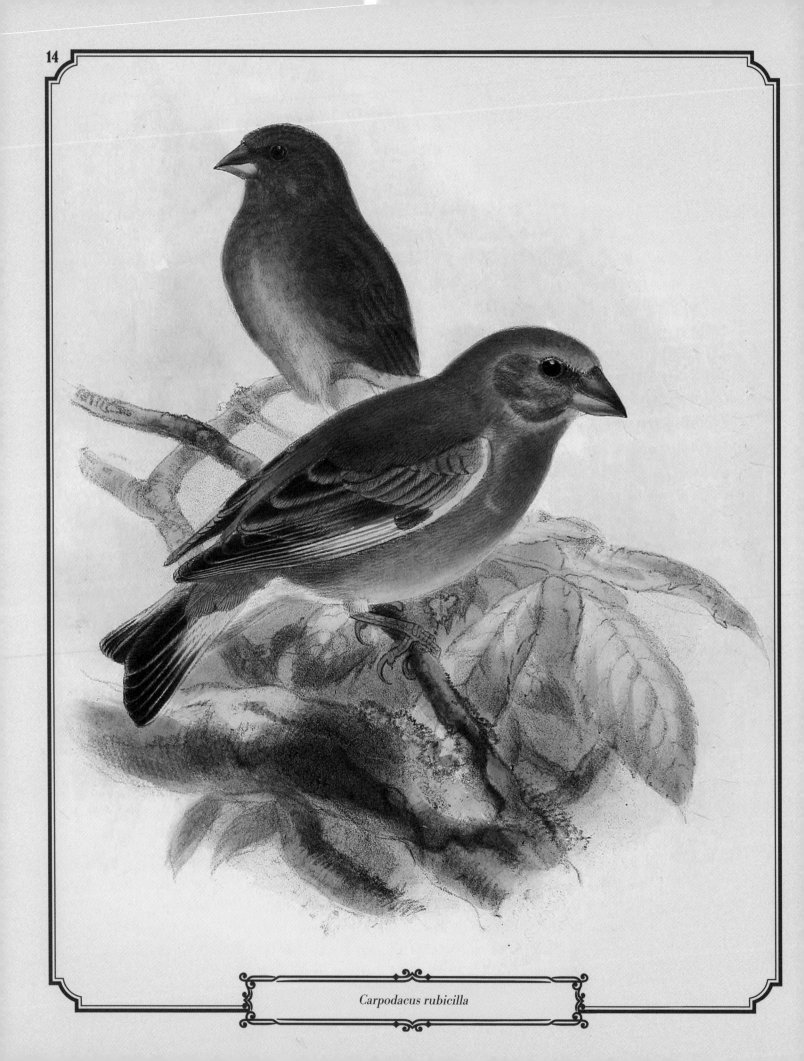

Carpodacus rubicilla

Caucasian great rosefinch

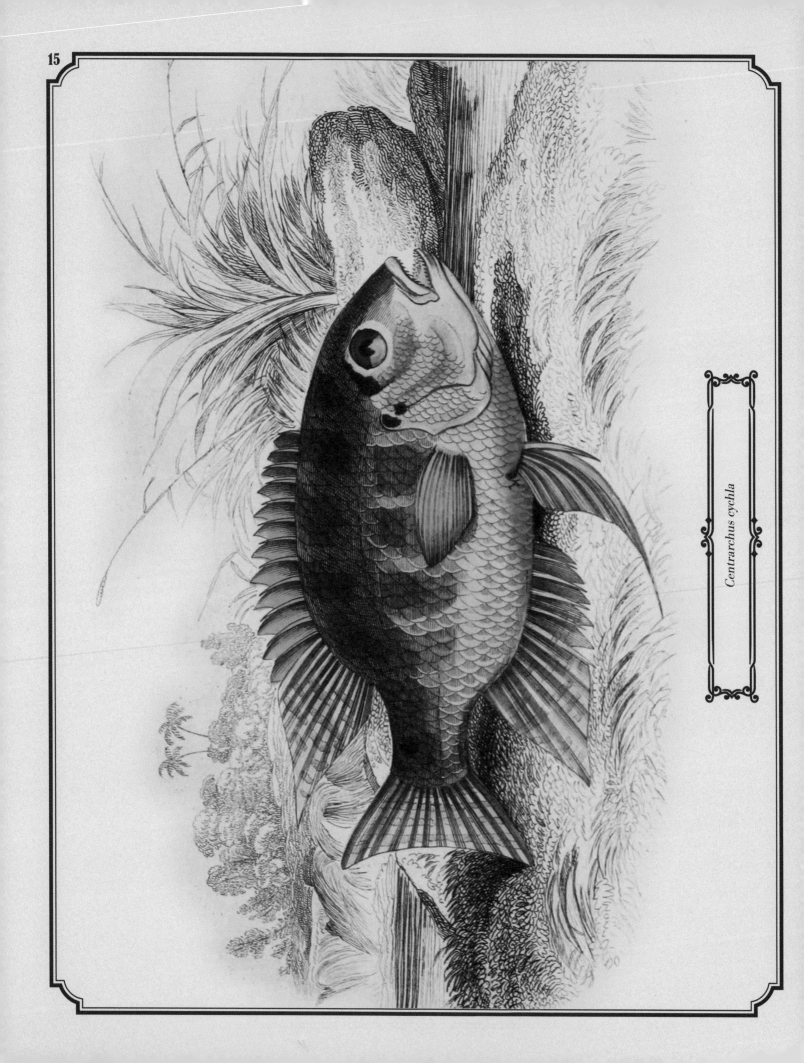

Centrarchus cychla

Cychla-like Centrarchus

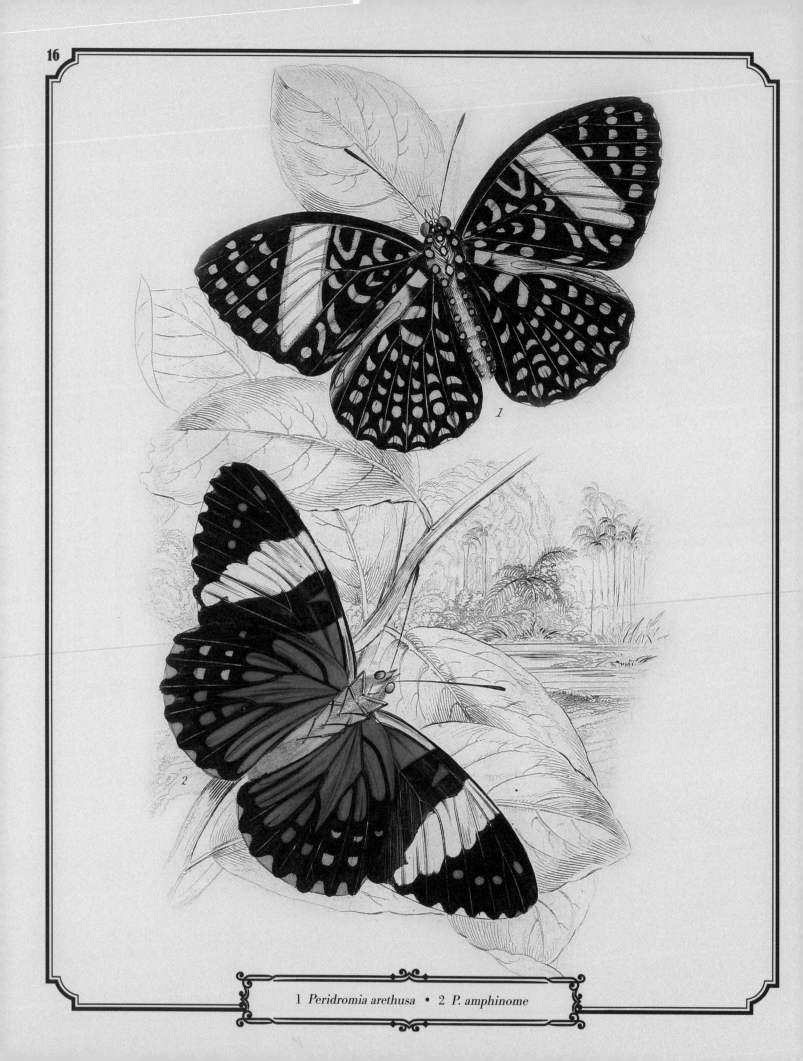

1 *Peridromia arethusa* • 2 *P. amphinome*

1 Peridromia arethusa • 2 P. amphinome

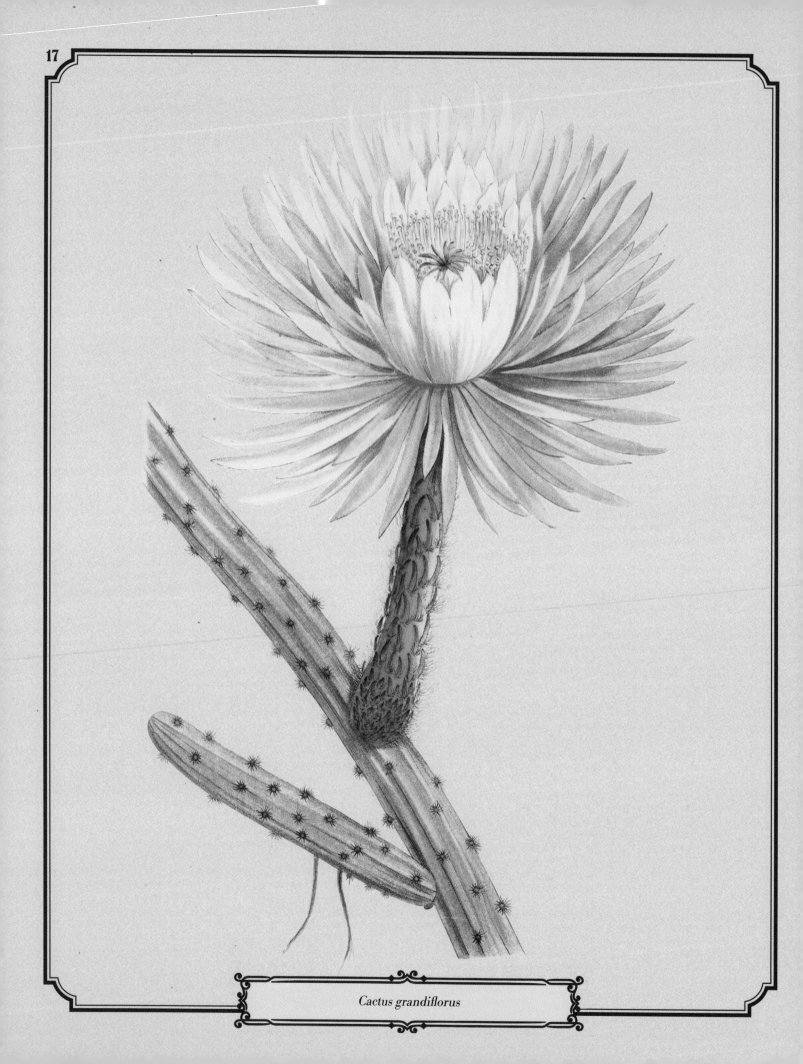

Cactus grandiflorus

Night-blooming cereus

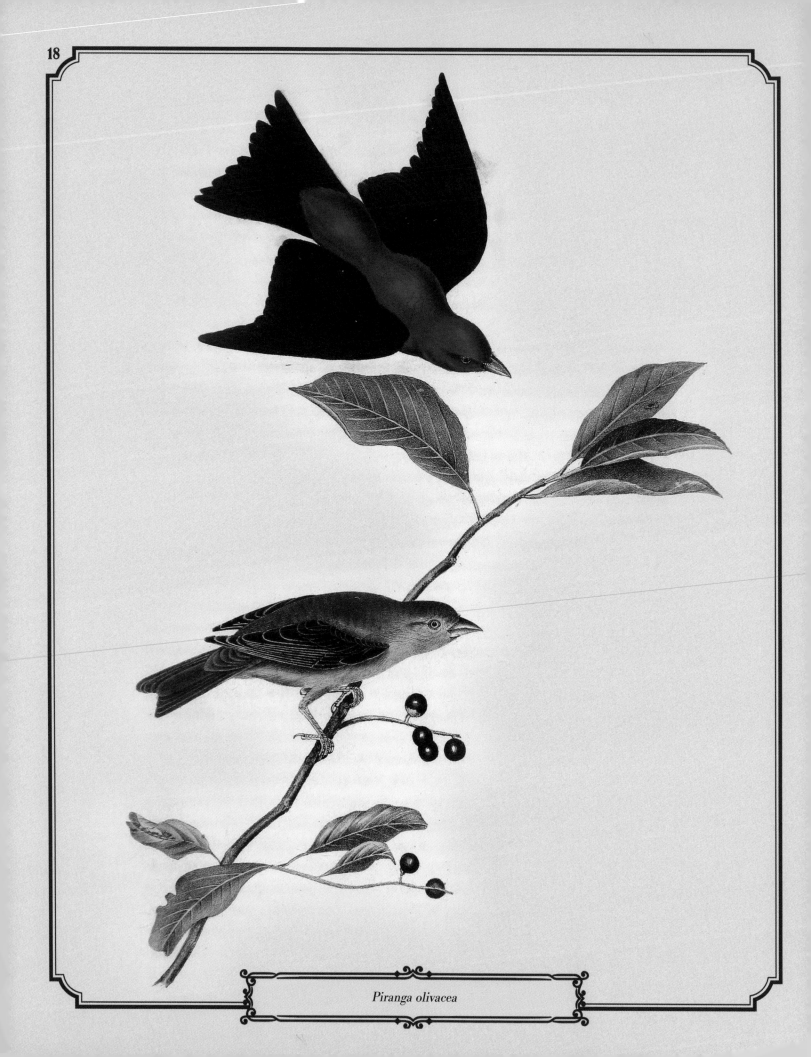

Piranga olivacea

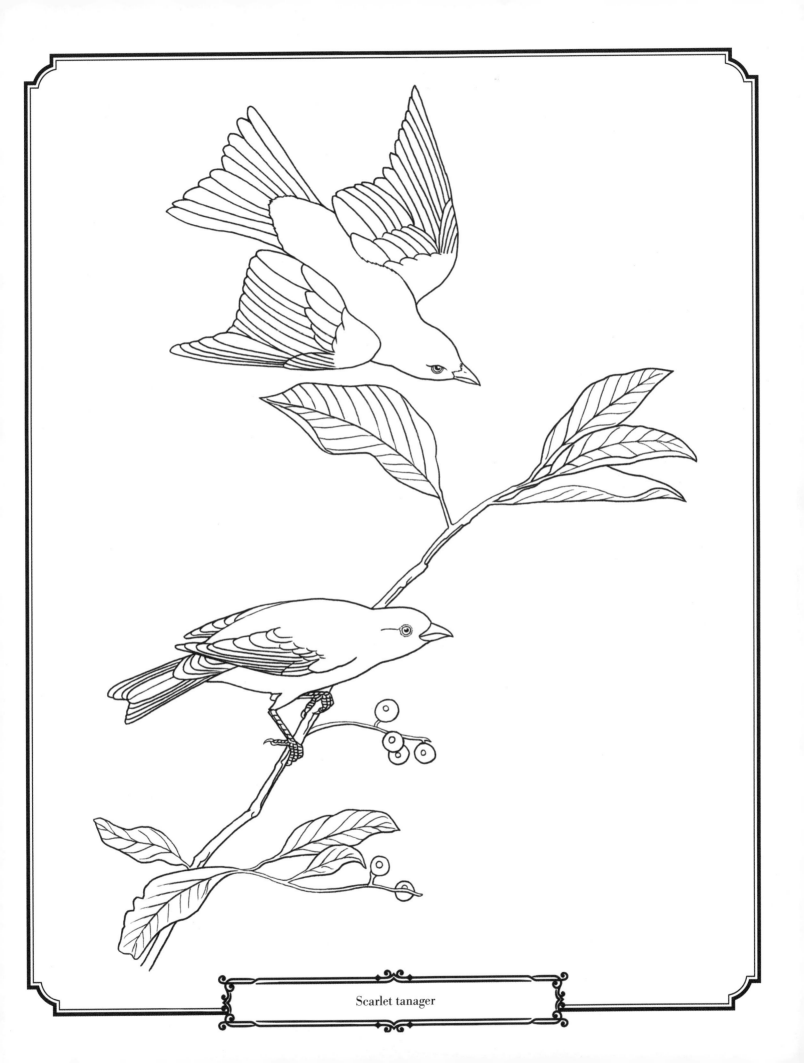

Scarlet tanager

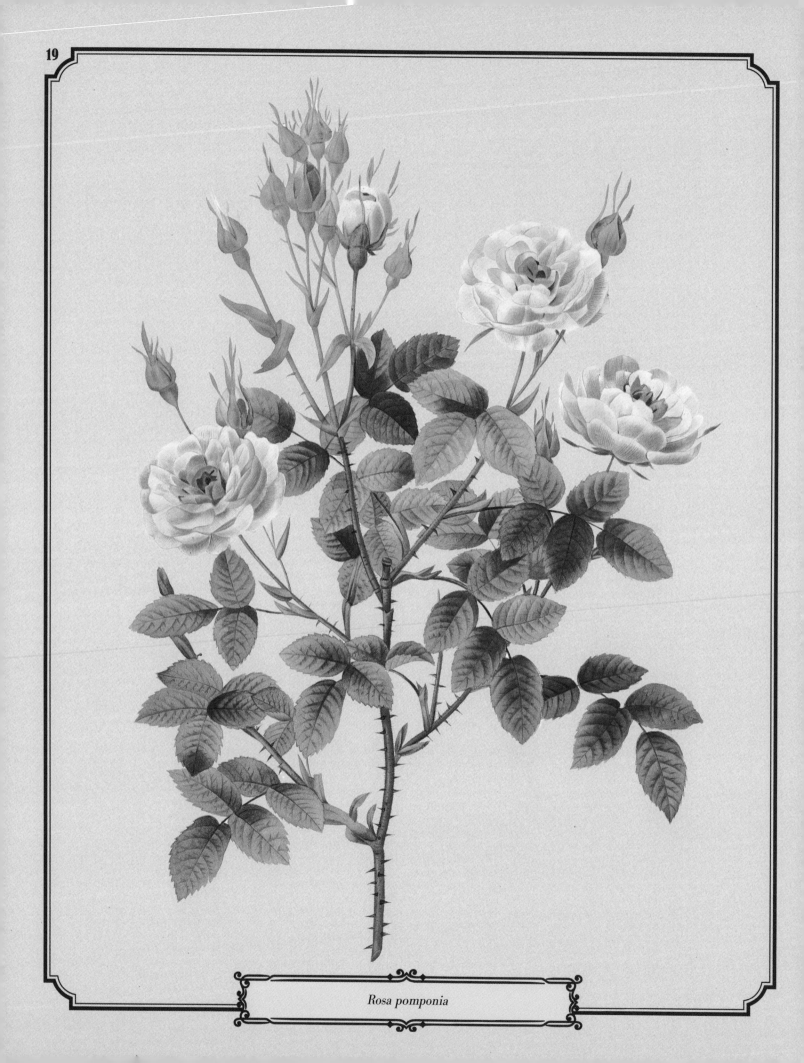

Rosa pomponia

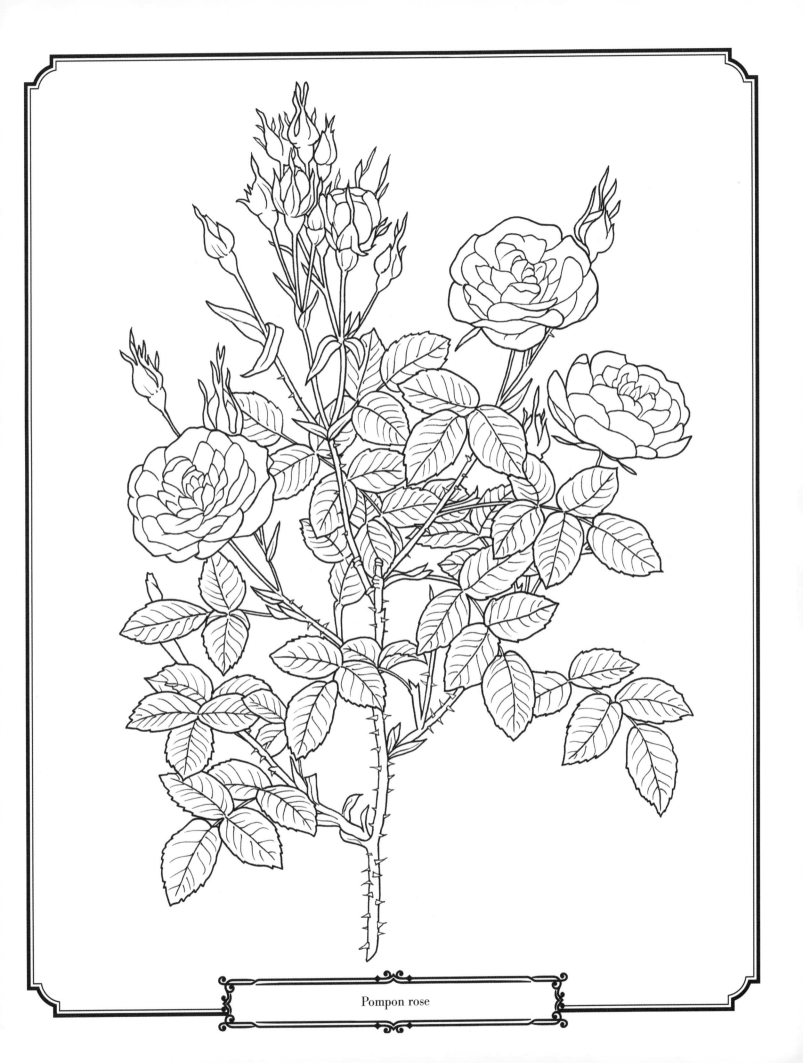

Pompon rose

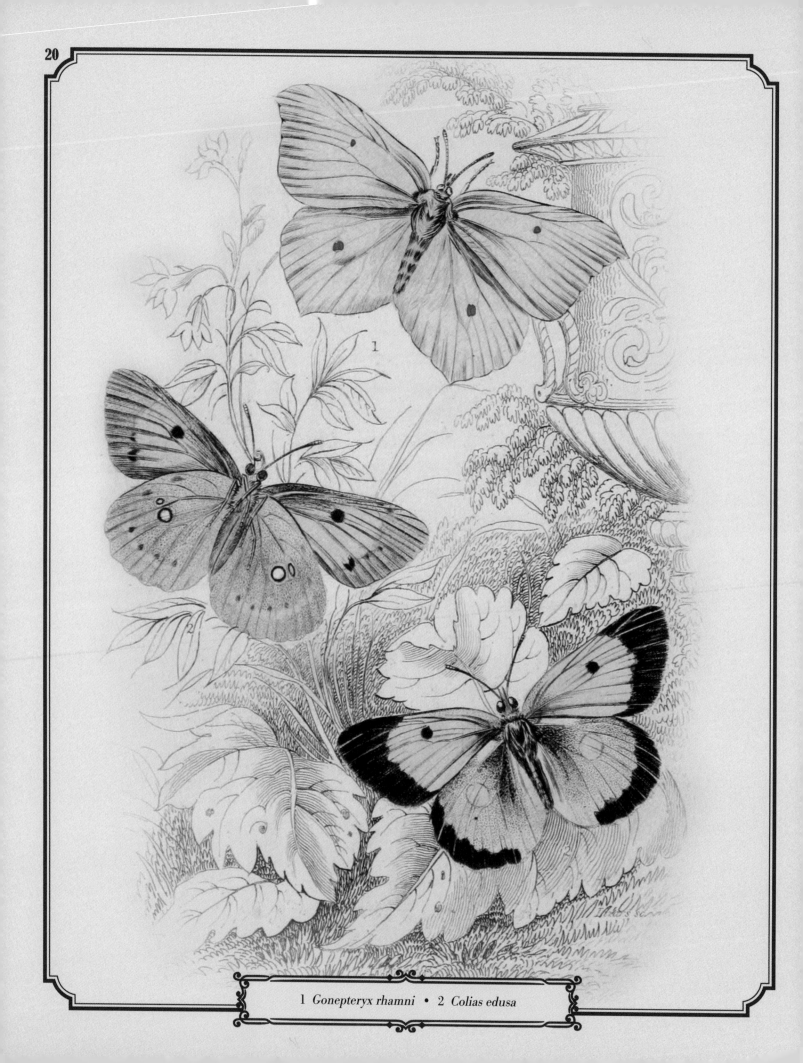

1 *Gonepteryx rhamni* • 2 *Colias edusa*

1 *Gonepteryx rhamni* • 2 *Colias edusa*

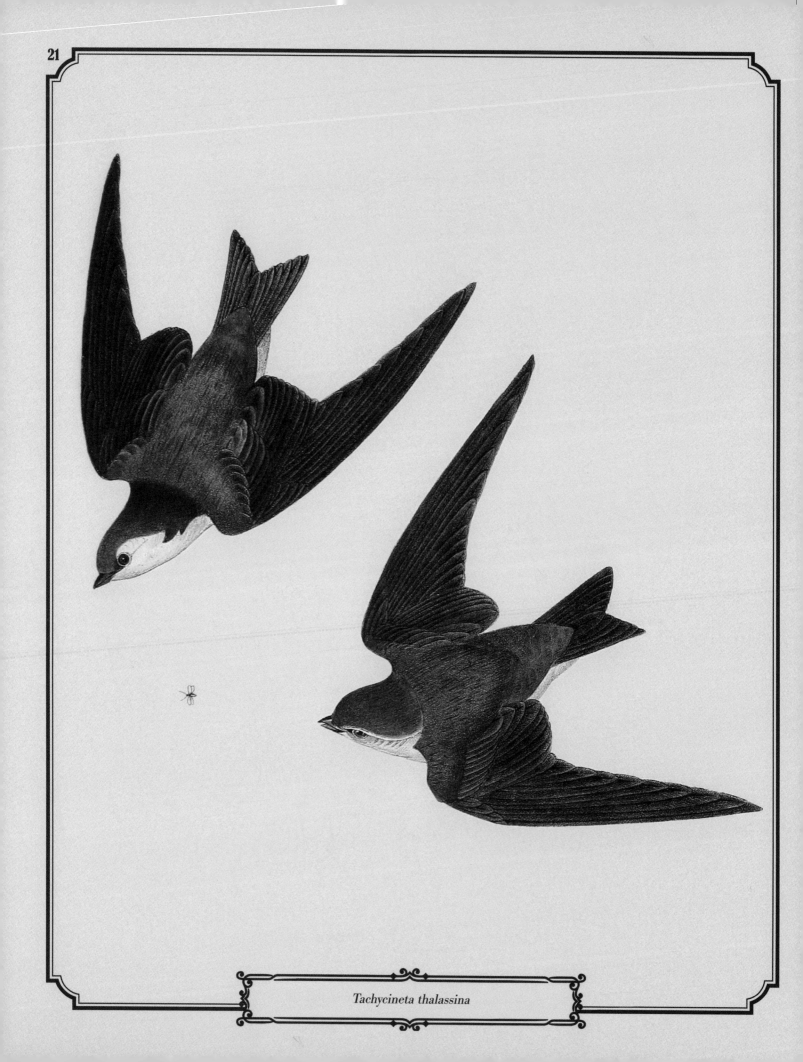

Tachycineta thalassina

Violet-green swallow

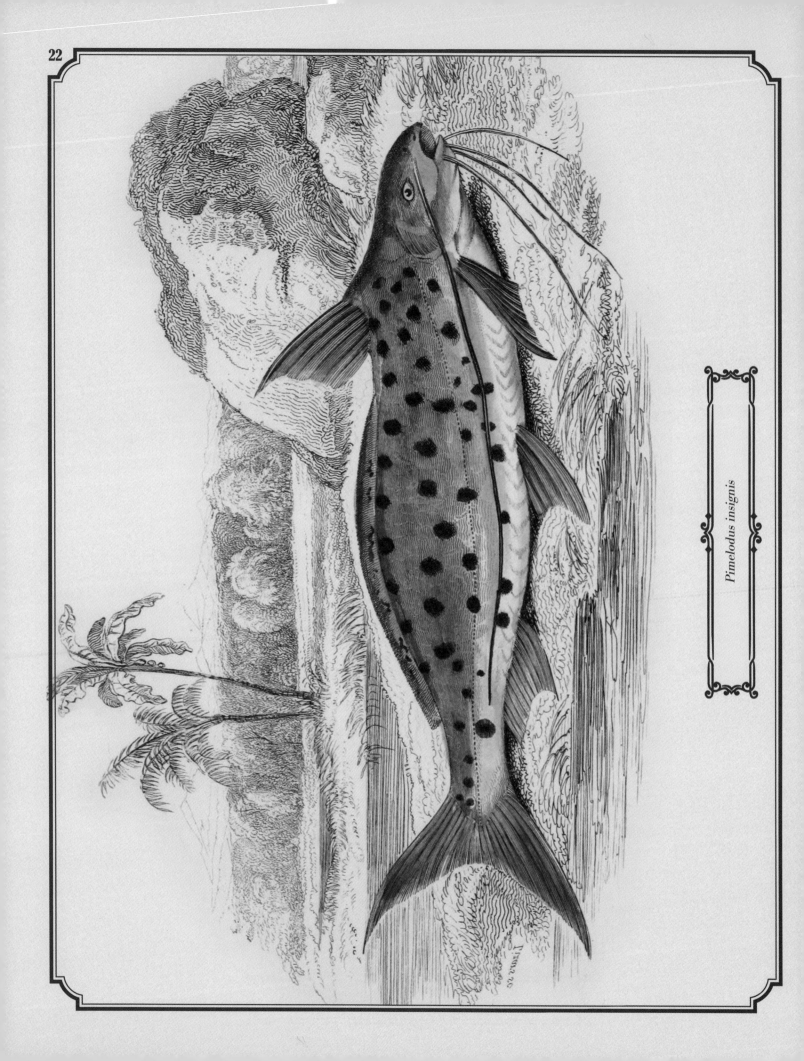

Pimelodus insignis

Blackspotted Green Pimelodus

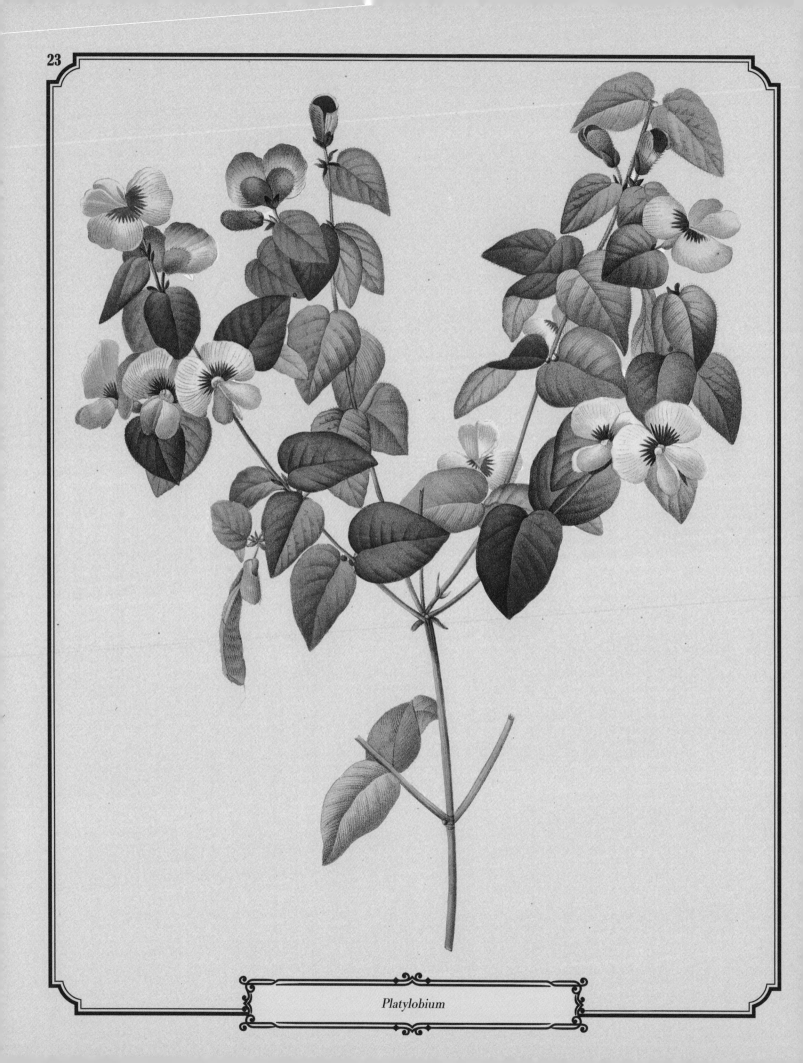

Platylobium

Flat-pea

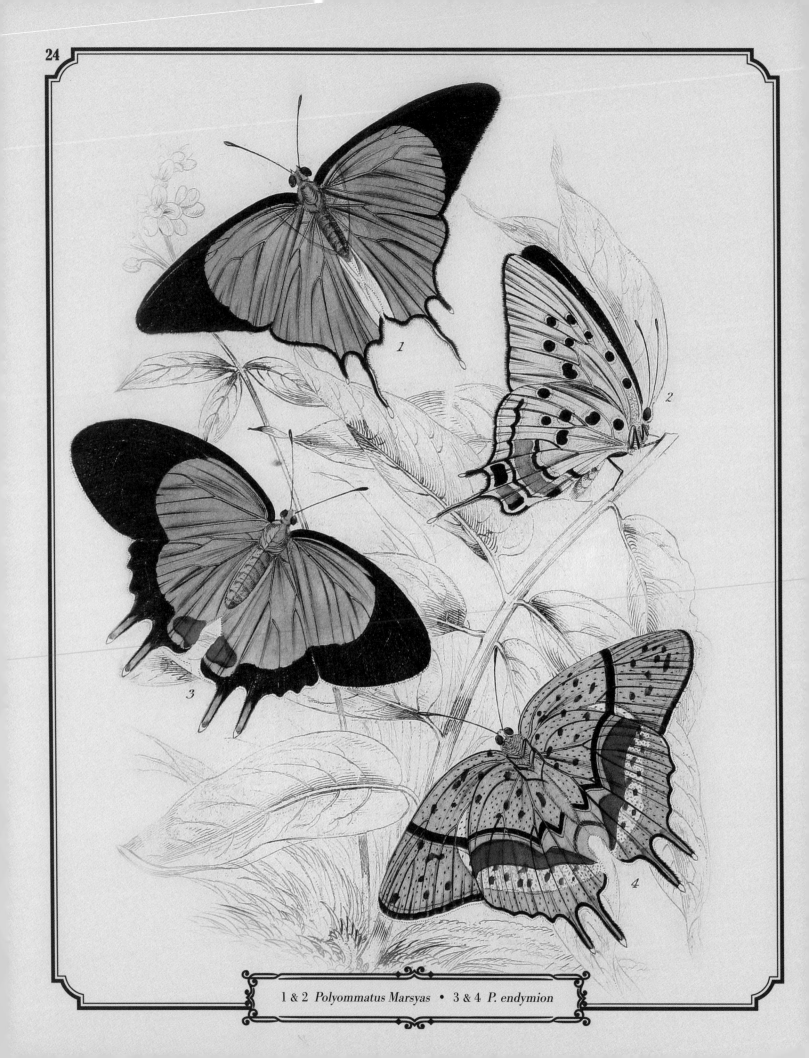

1 & 2 *Polyommatus Marsyas* • 3 & 4 *P. endymion*

1 & 2 *Polyommatus Marsyas* • 3 & 4 *P. endymion*

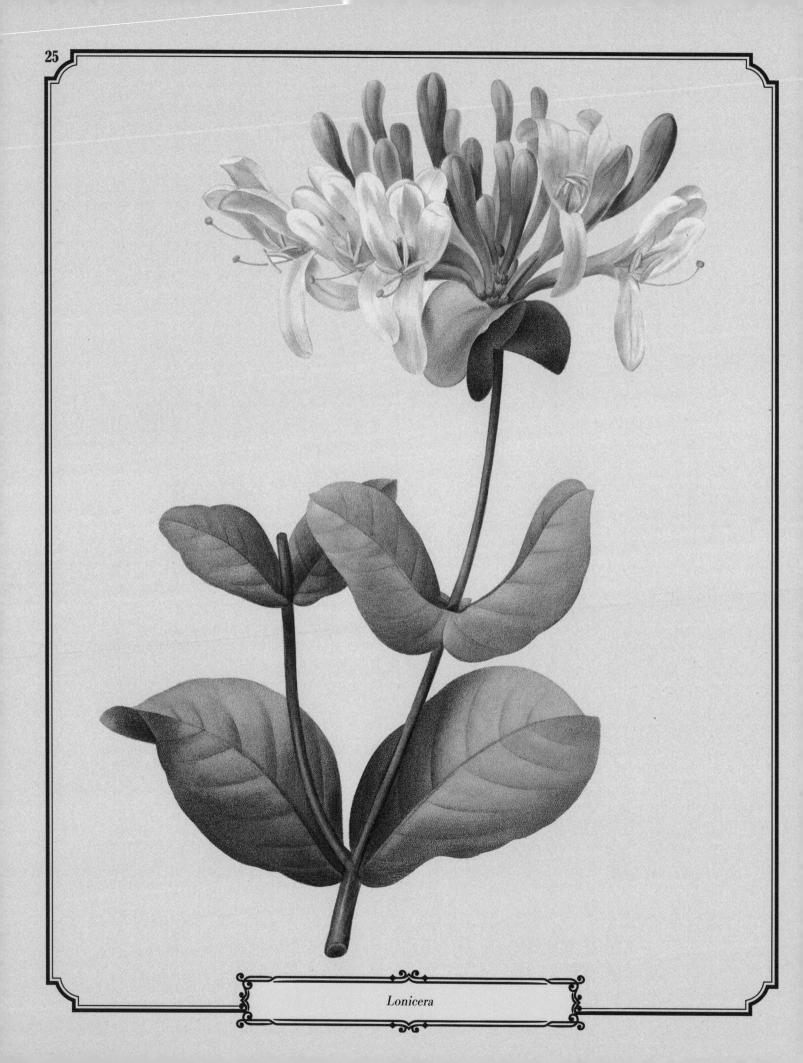

Lonicera

Honeysuckle

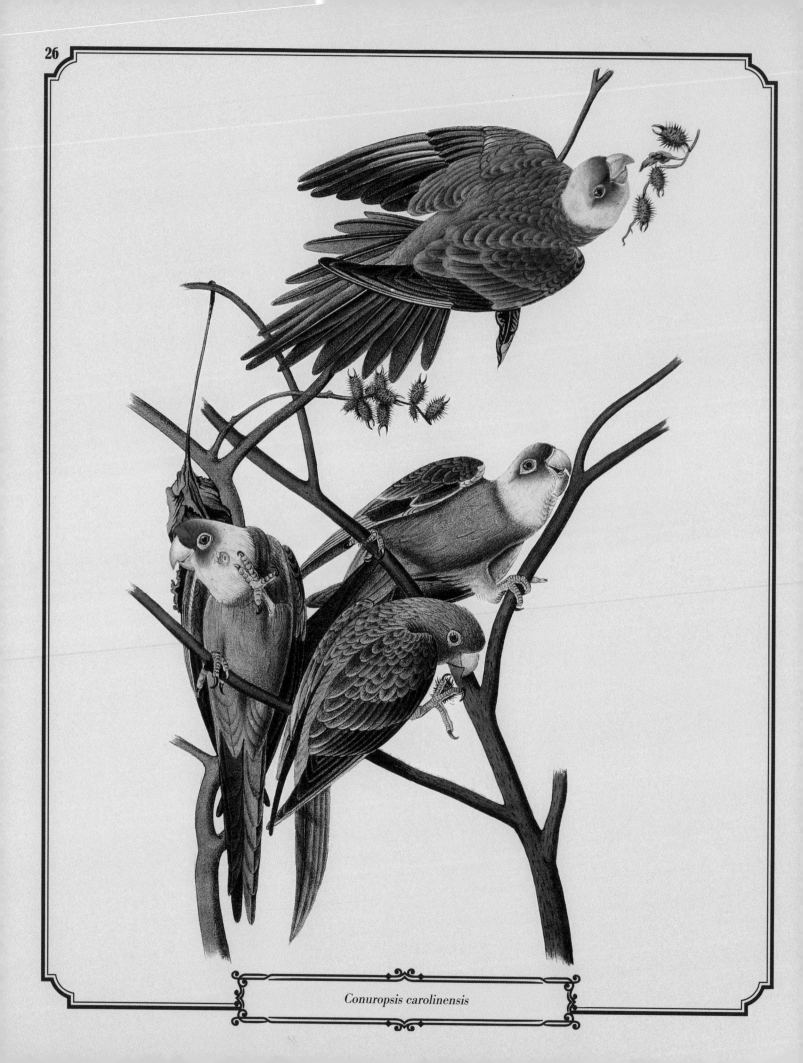

Conuropsis carolinensis

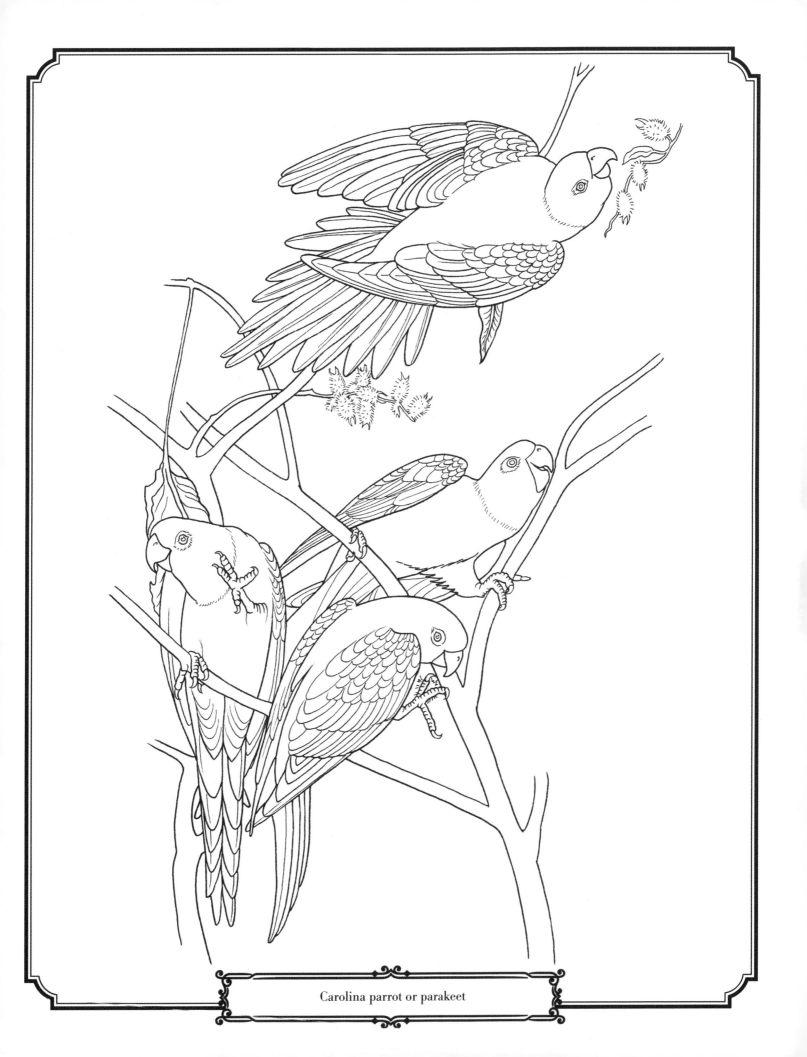

Carolina parrot or parakeet

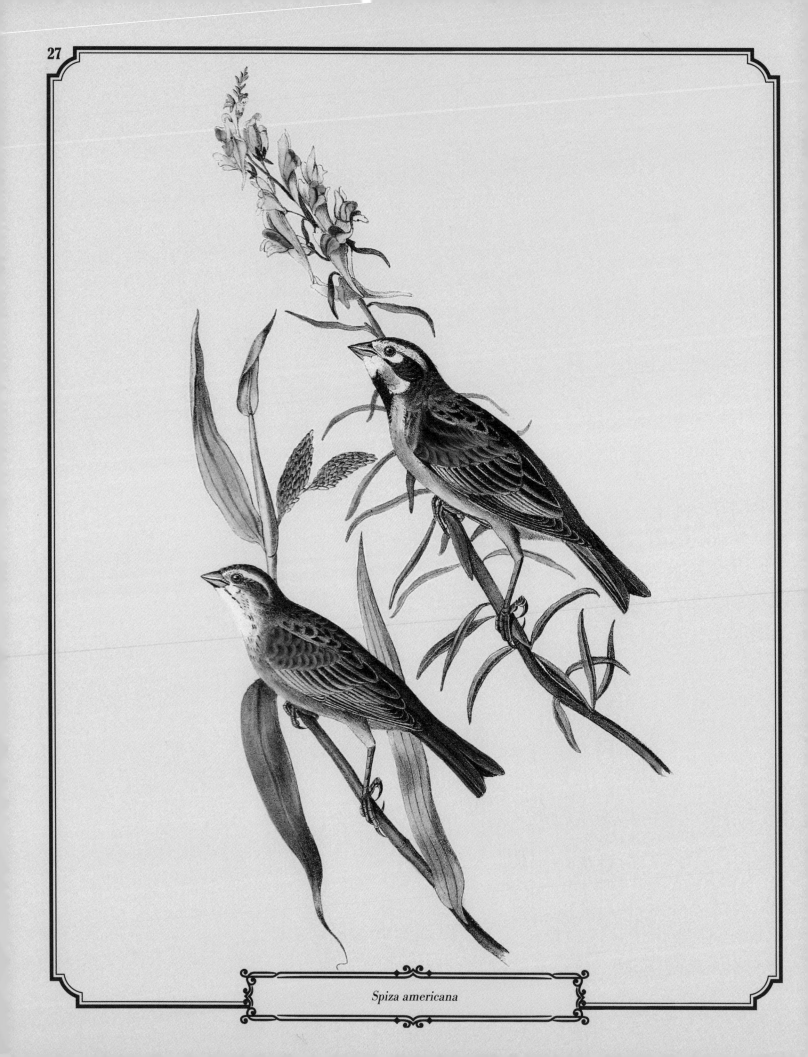

Spiza americana

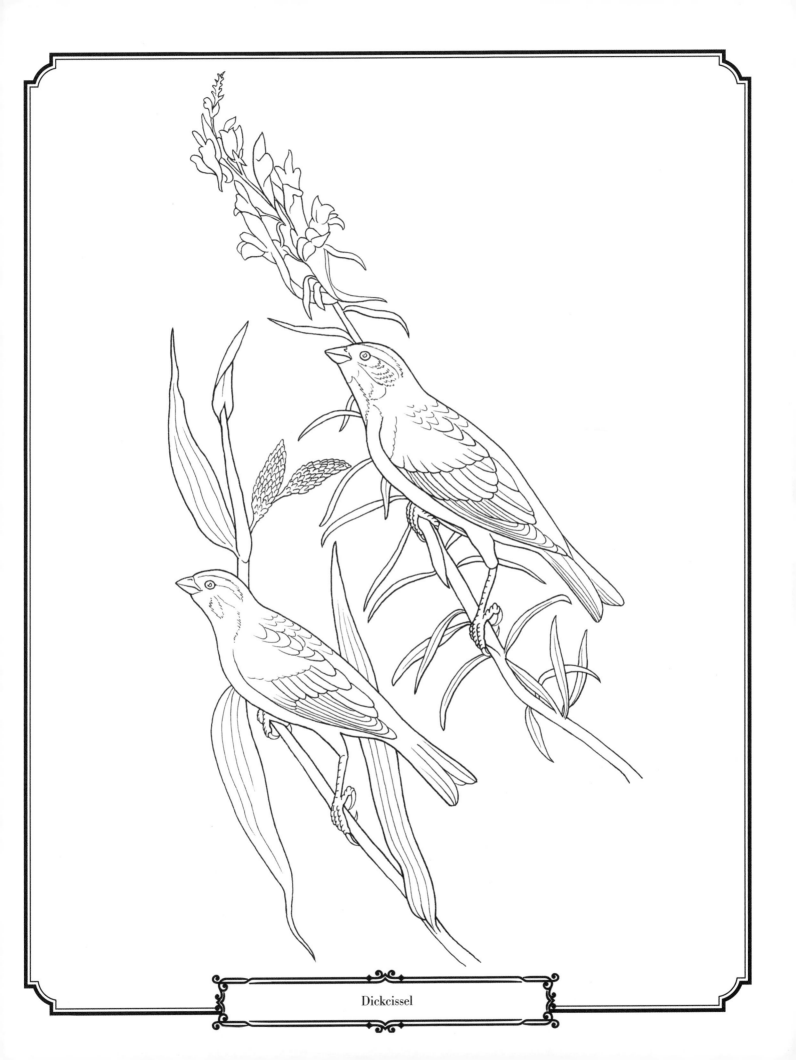

Dickcissel

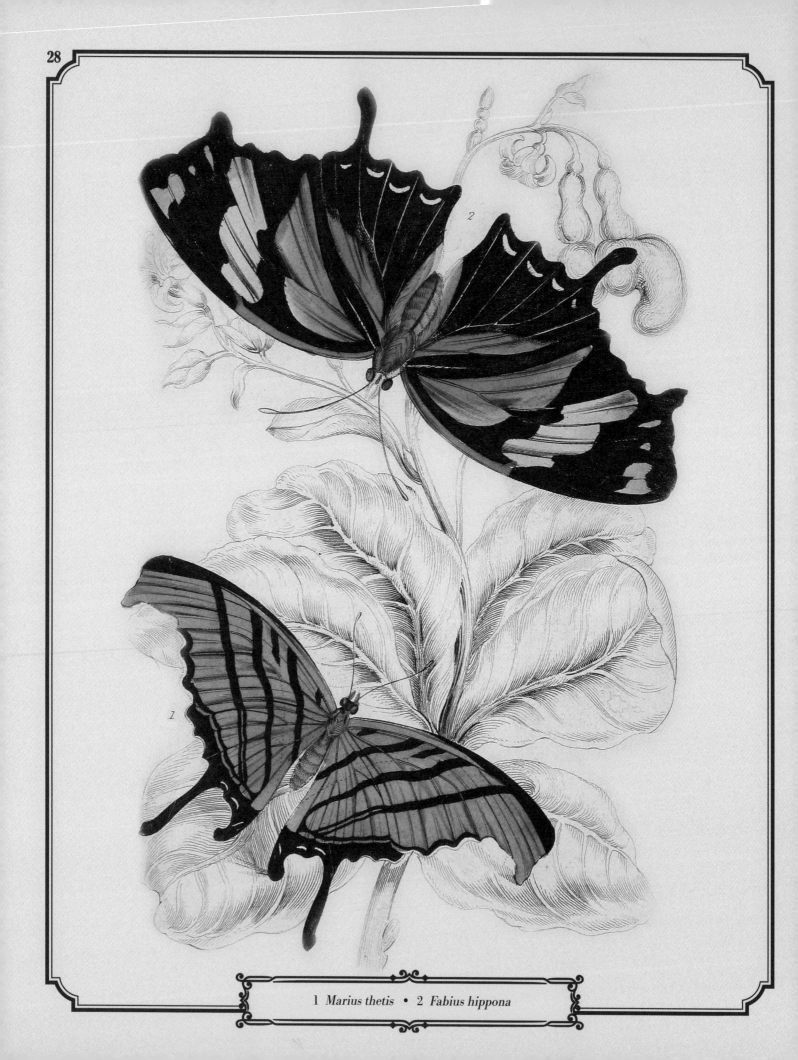

1 *Marius thetis* • 2 *Fabius hippona*

1 Marius thetis • 2 Fabius hippona

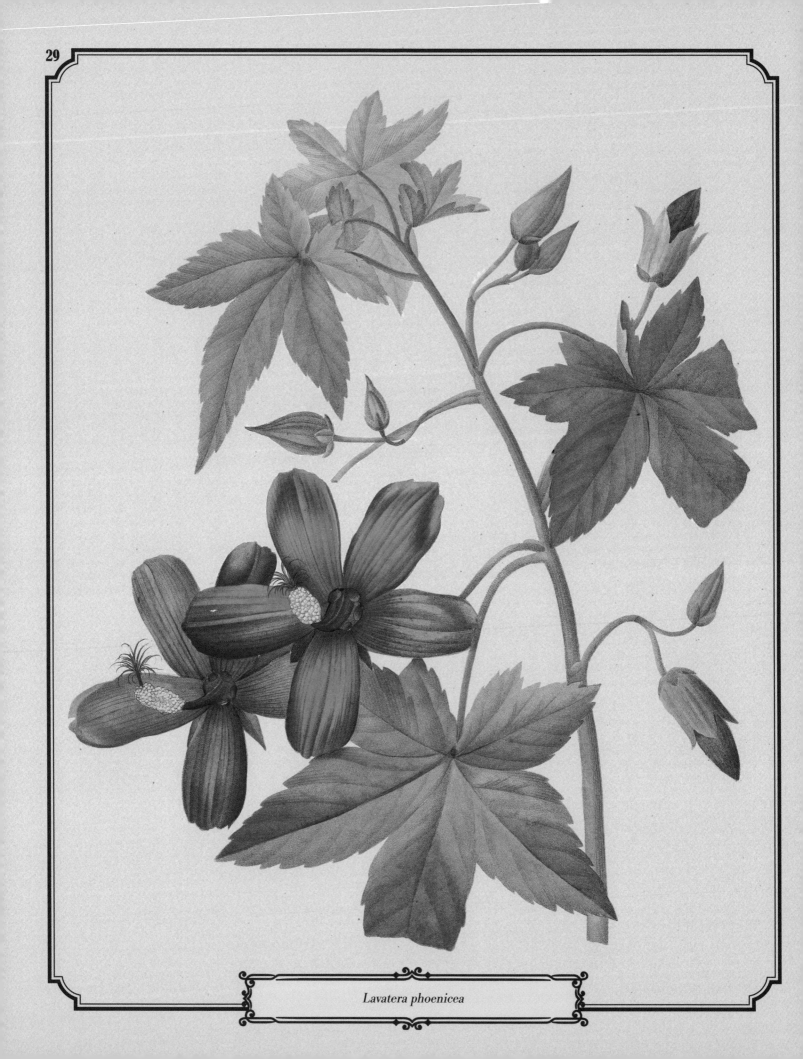

Lavatera phoenicea

Tree mallow

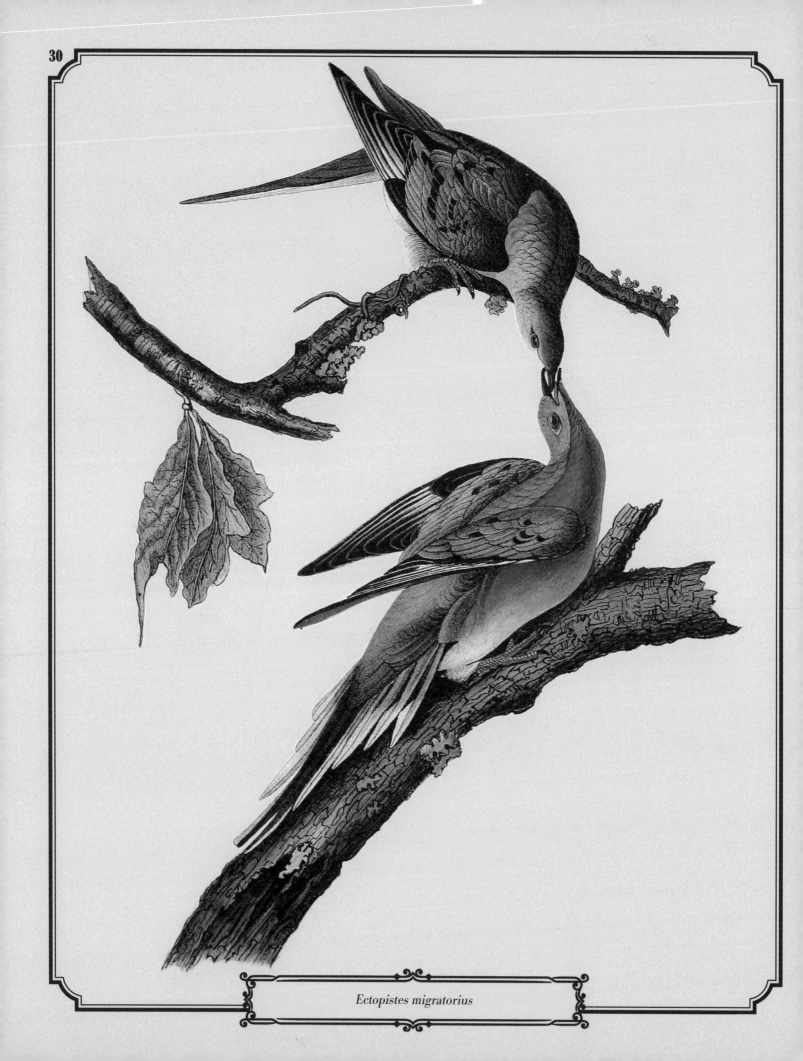

Ectopistes migratorius

Passenger pigeon

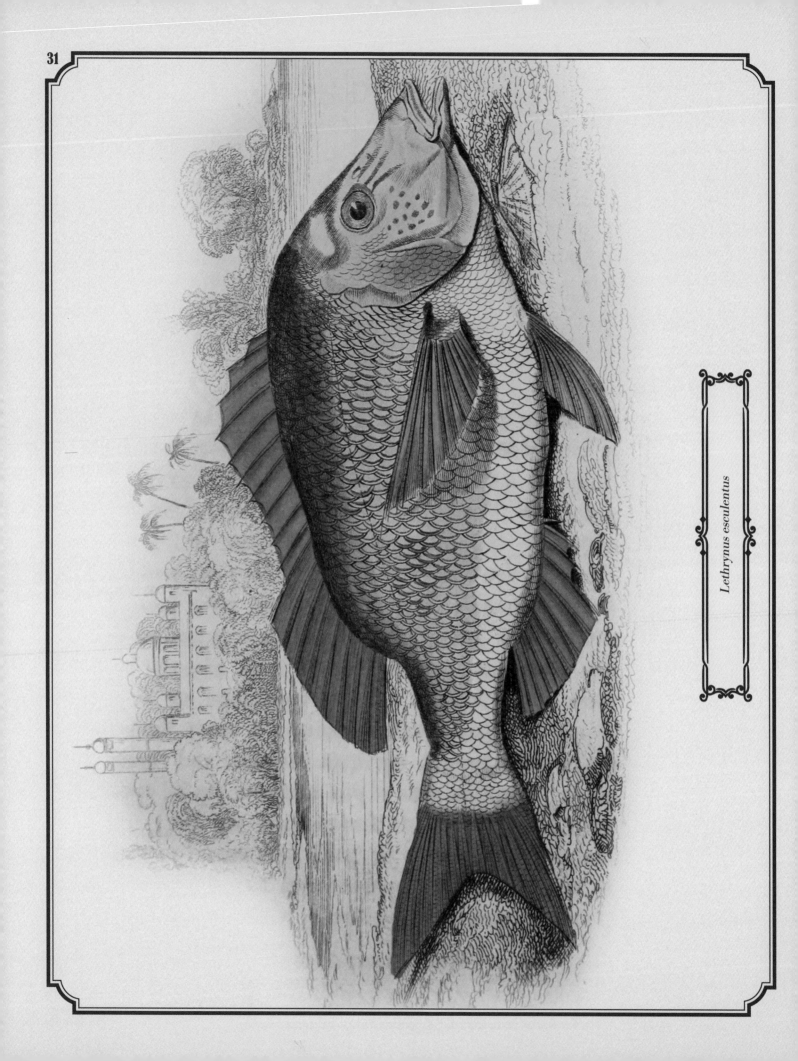

Lethrynus esculentus

Edible Lethrynus

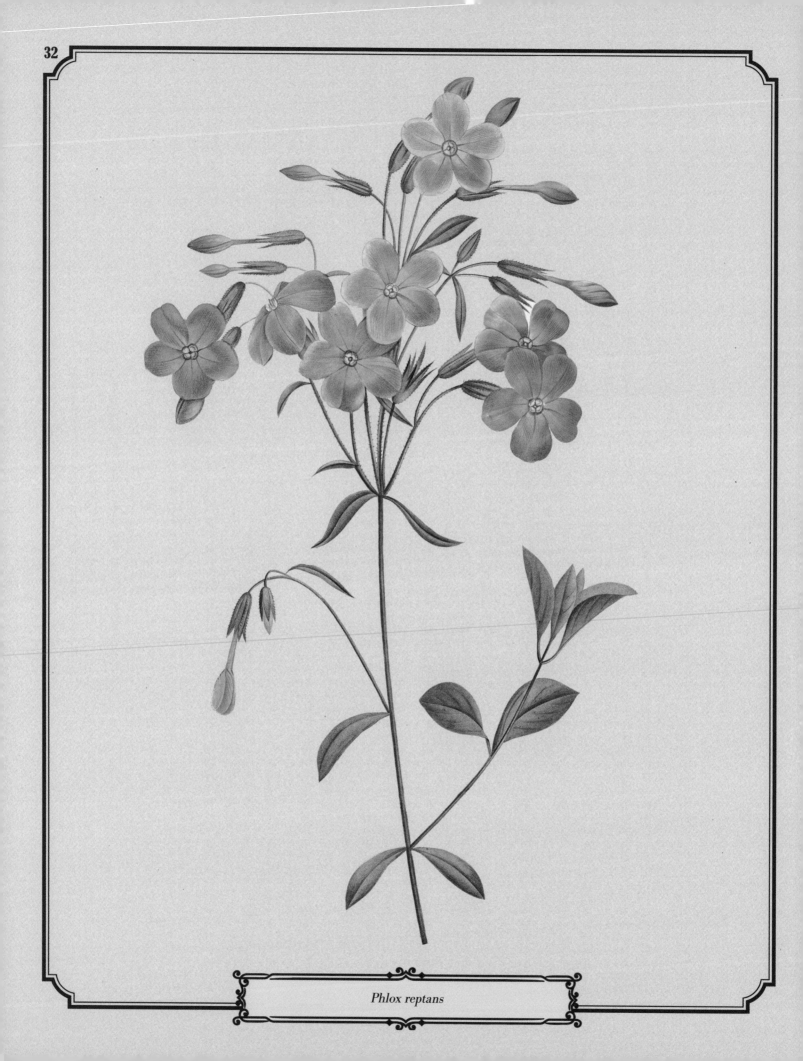

Phlox reptans

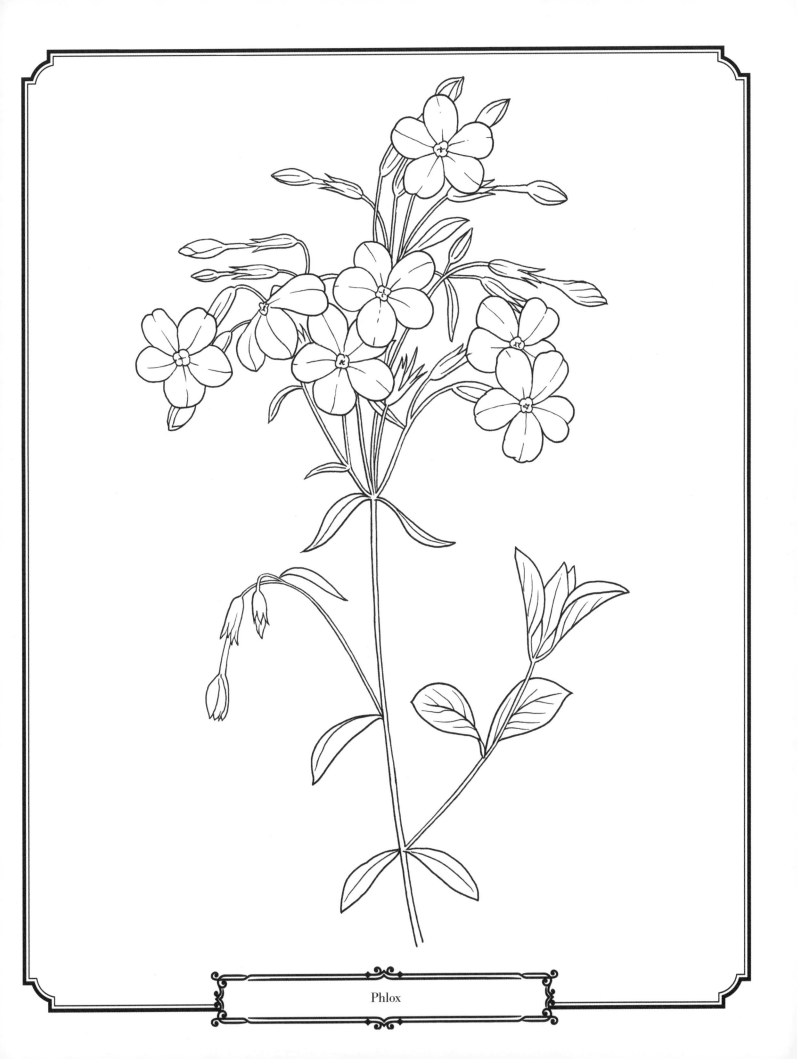

Phlox

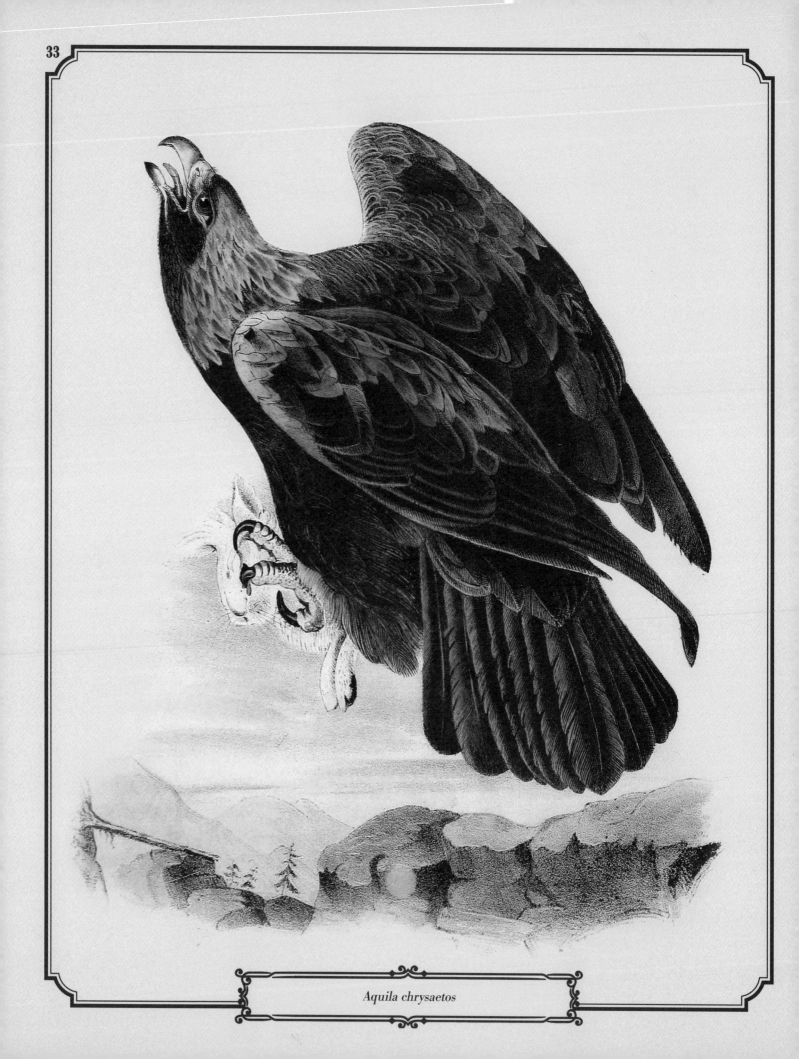

Aquila chrysaetos

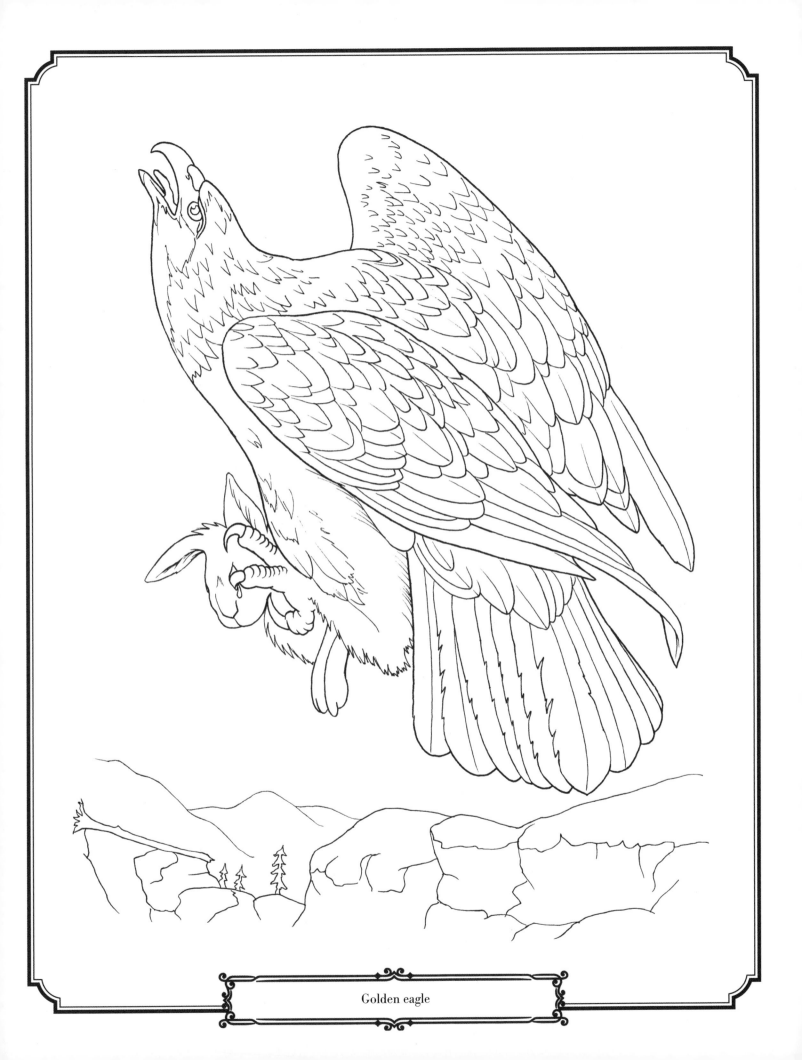

Golden eagle

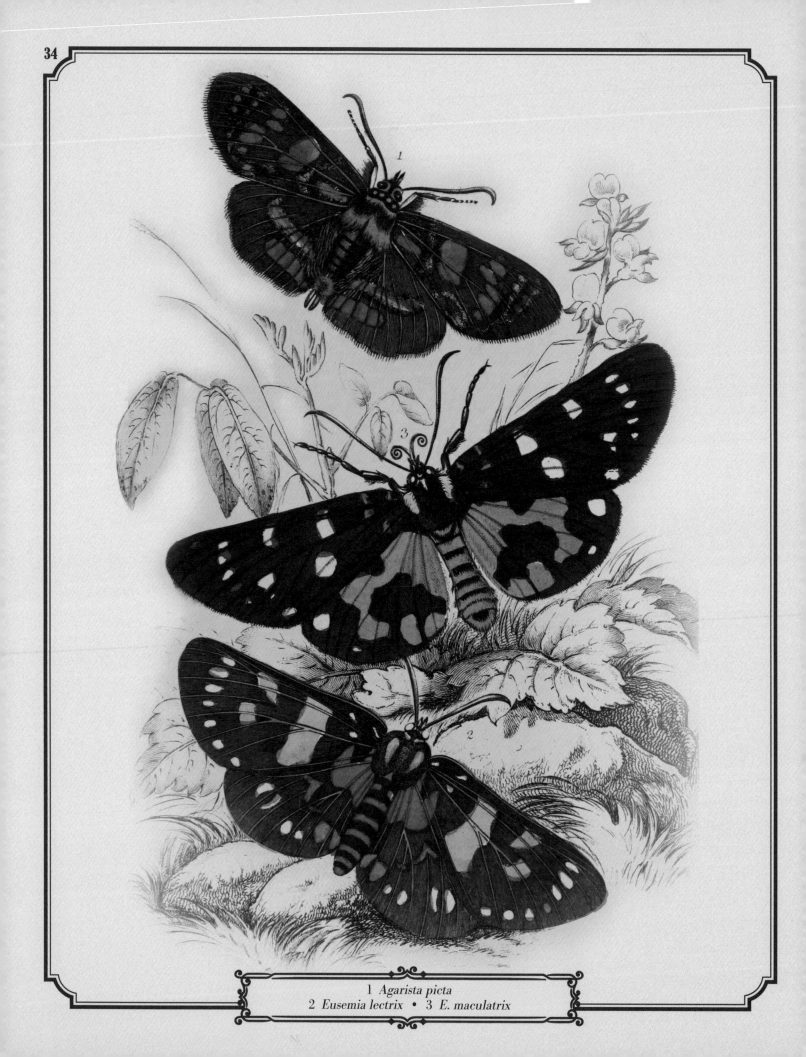

1 *Agarista picta*
2 *Eusemia lectrix* • 3 *E. maculatrix*

1 *Agarista picta*
2 *Eusemia lectrix* • 3 *E. maculatrix*

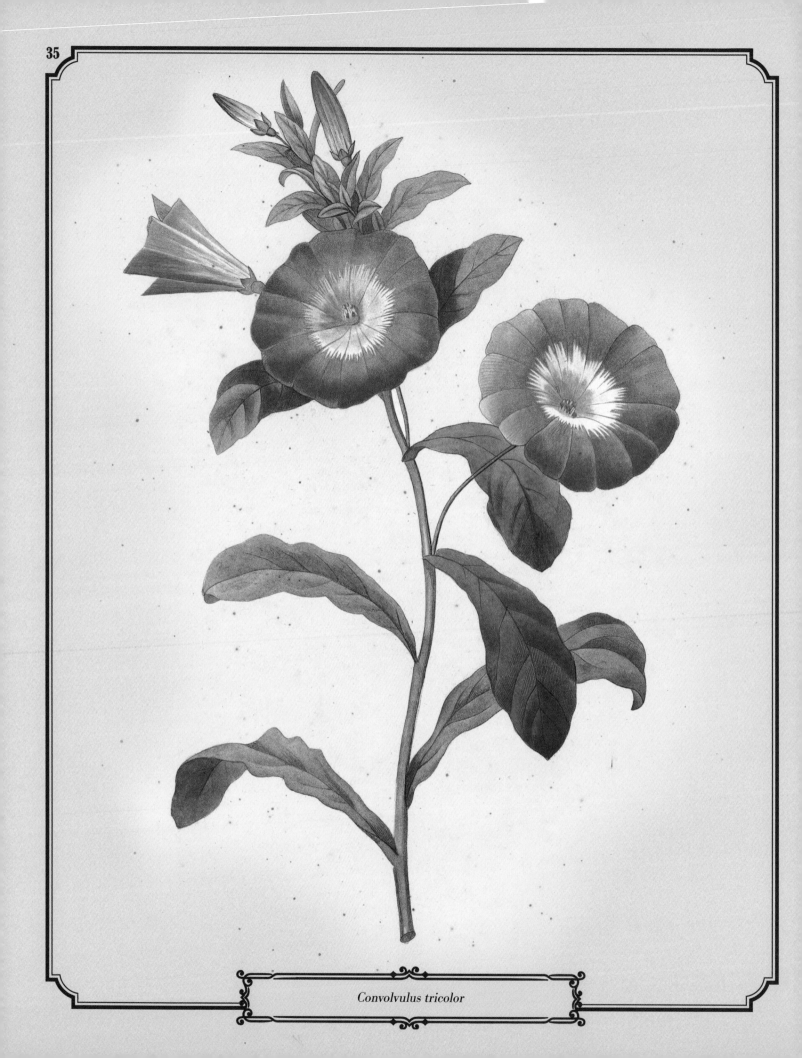

Convolvulus tricolor

Dwarf morning glory

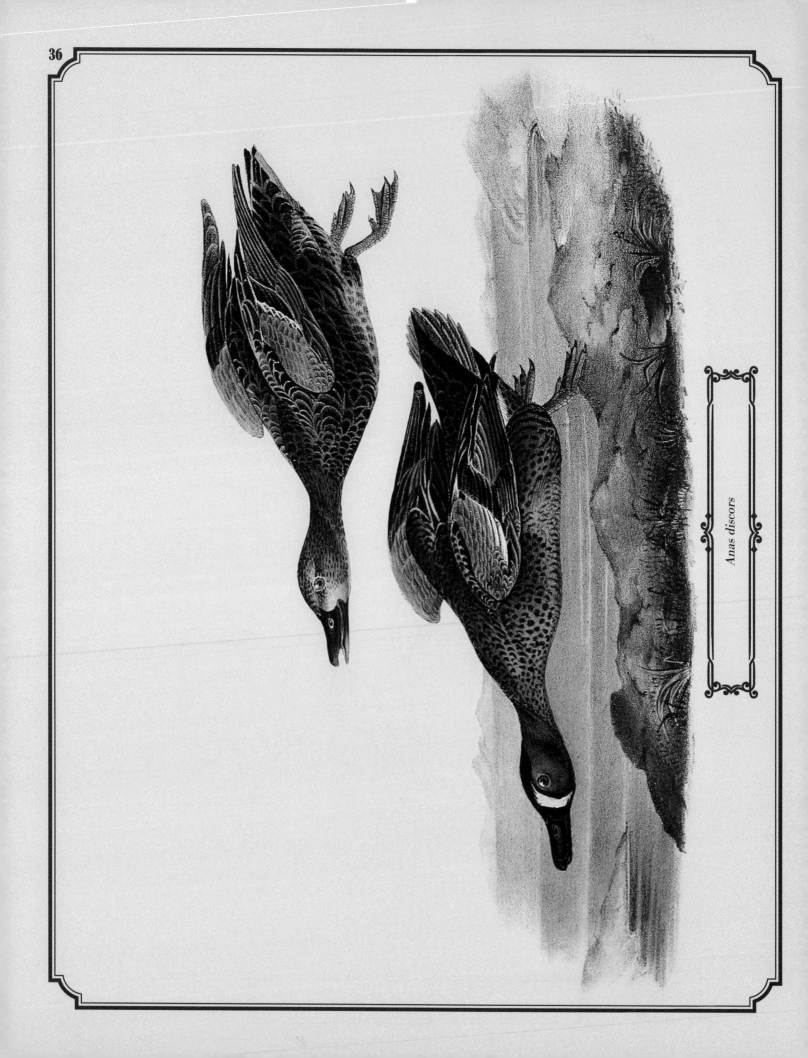

Anas discors

Blue-winged teal

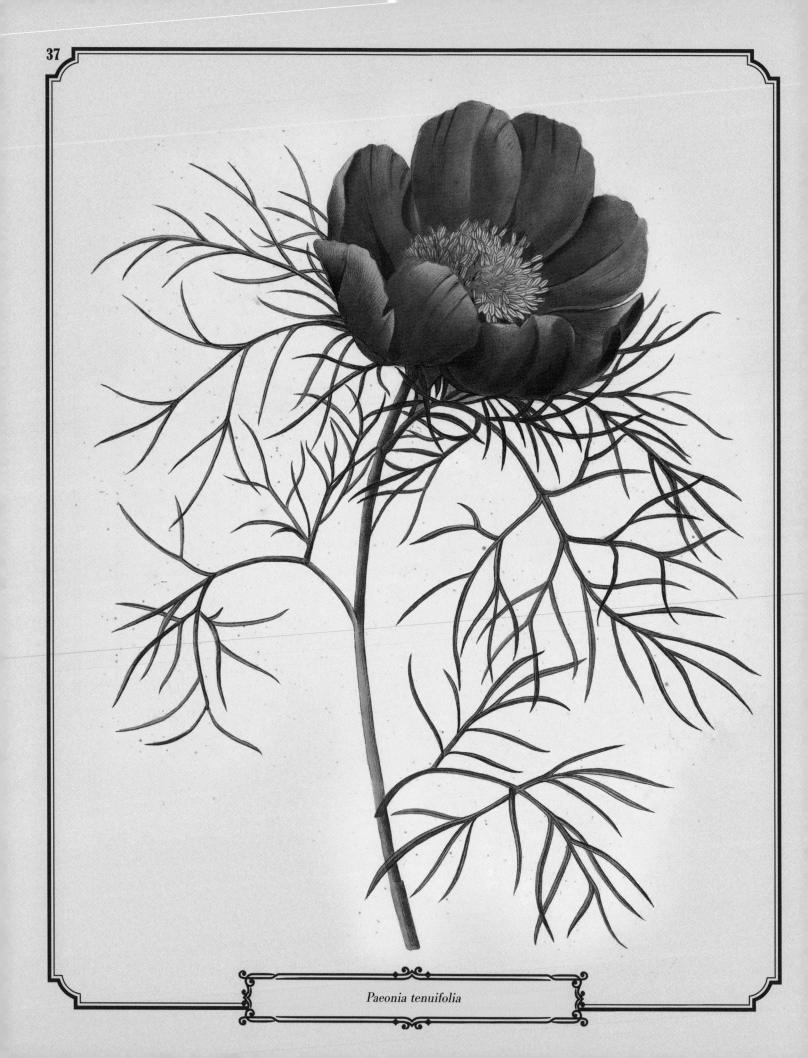

Paeonia tenuifolia

Fern-leaf peony

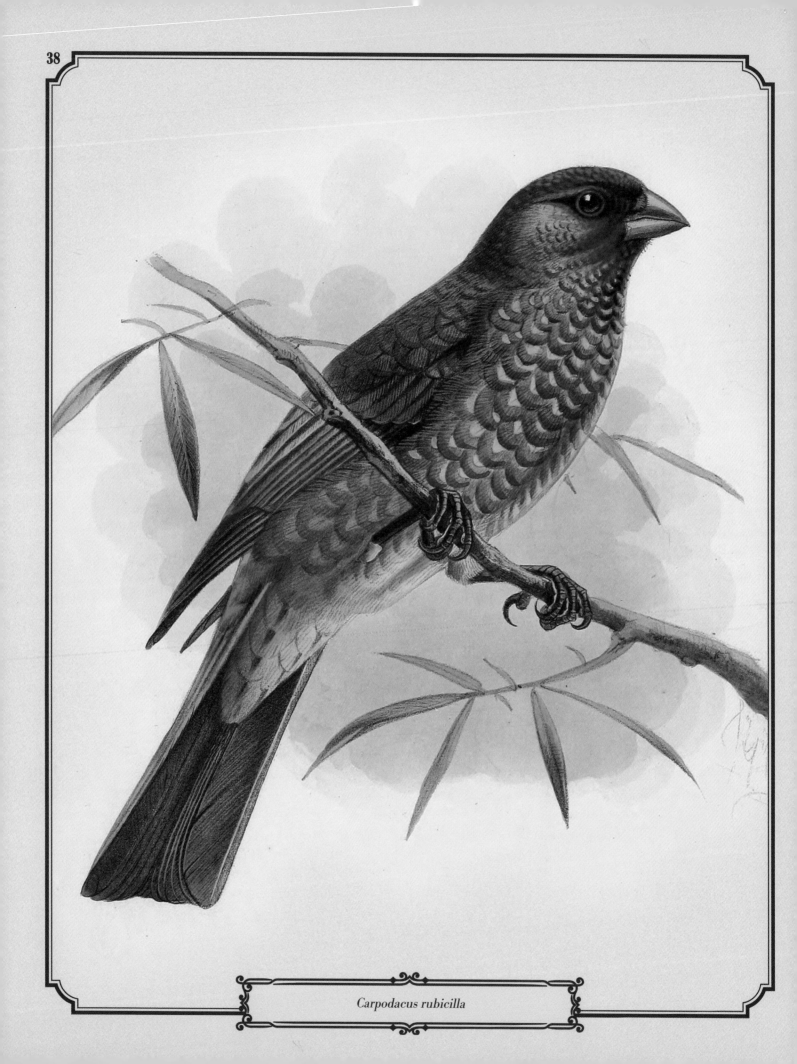

Carpodacus rubicilla

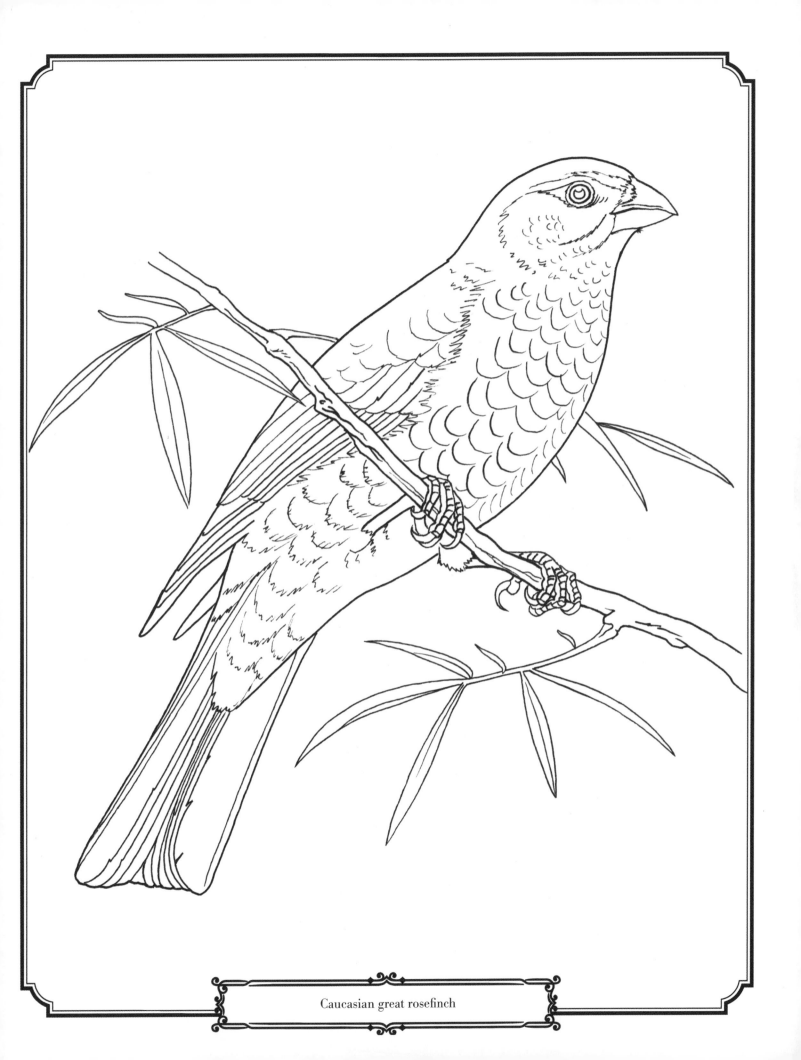

Caucasian great rosefinch

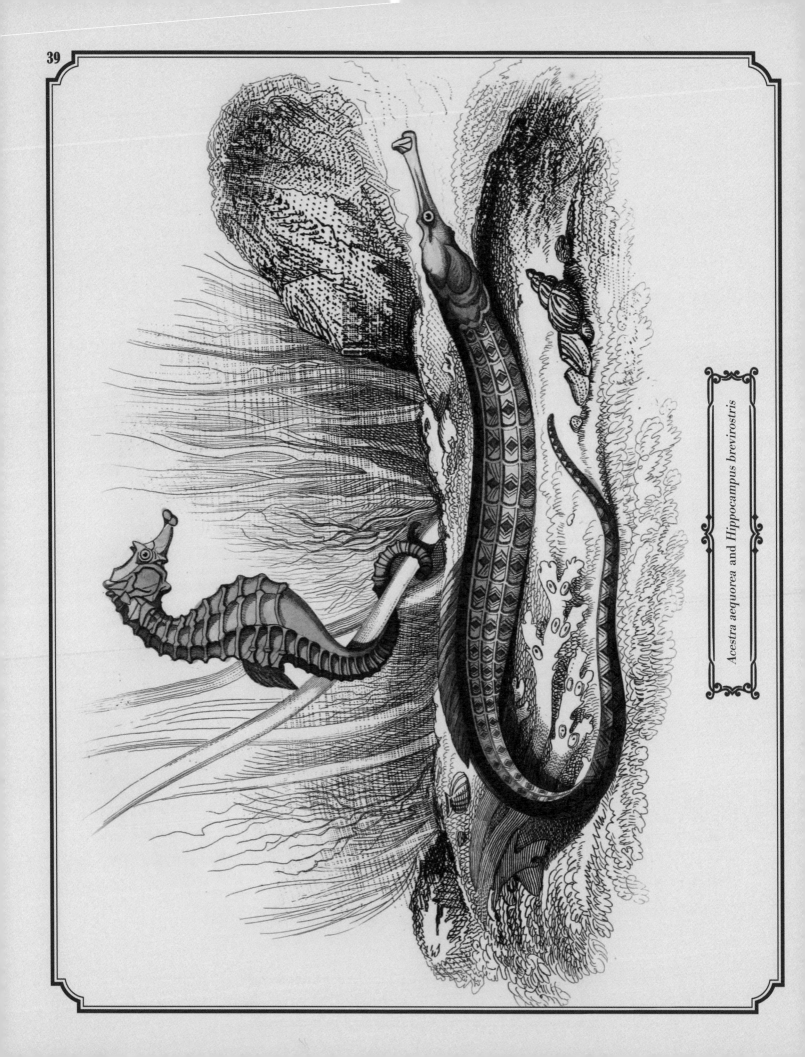

Acestra aequorea and *Hippocampus brevirostris*

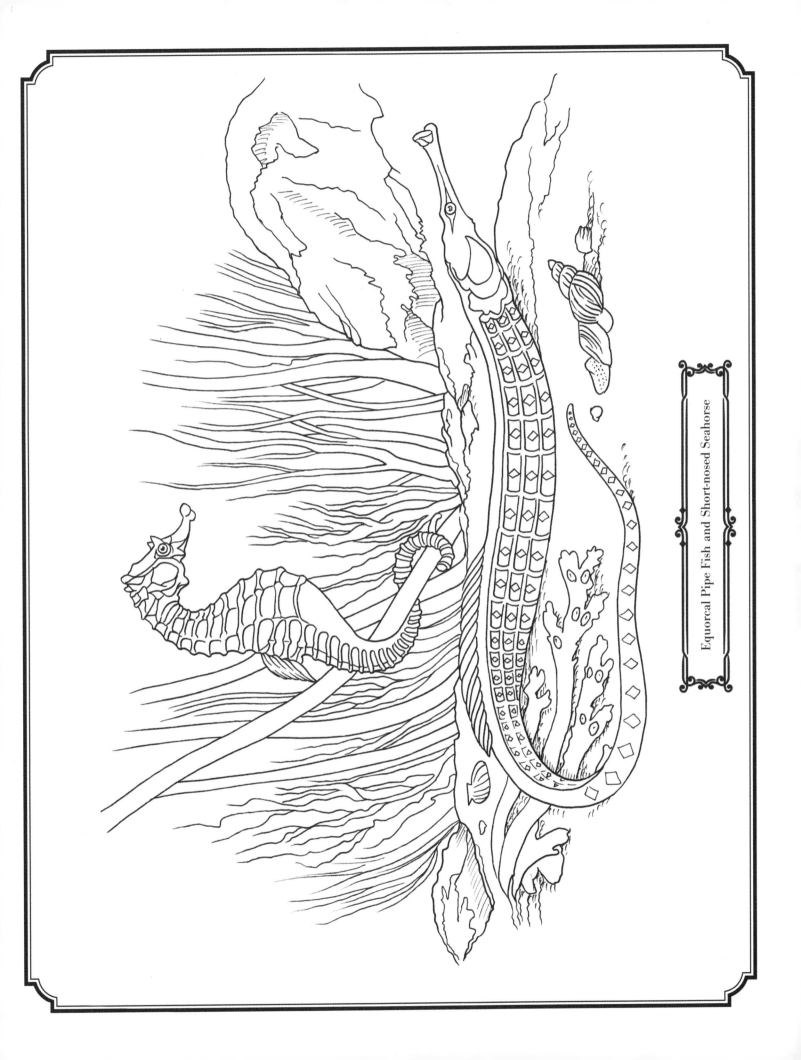

Equoreal Pipe Fish and Short-nosed Seahorse

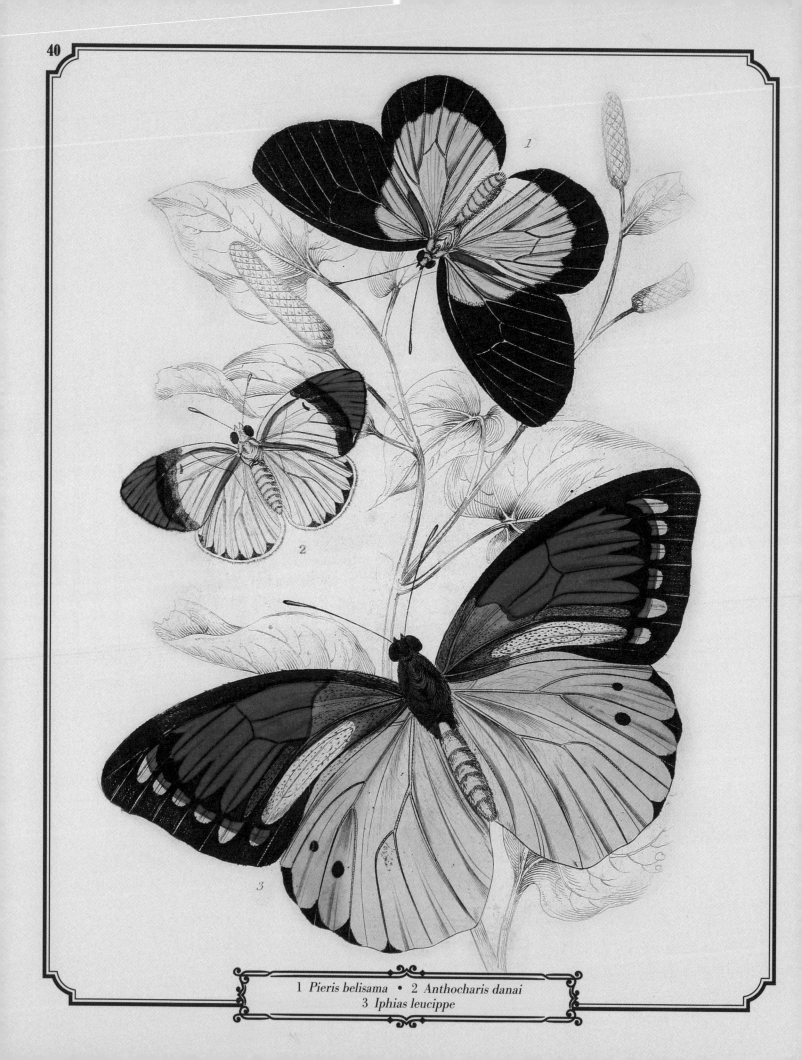

1 *Pieris belisama* • 2 *Anthocharis danai*
3 *Iphias leucippe*

1 *Pieris belisama* • 2 *Anthocharis danai*
3 *Iphias leucippe*

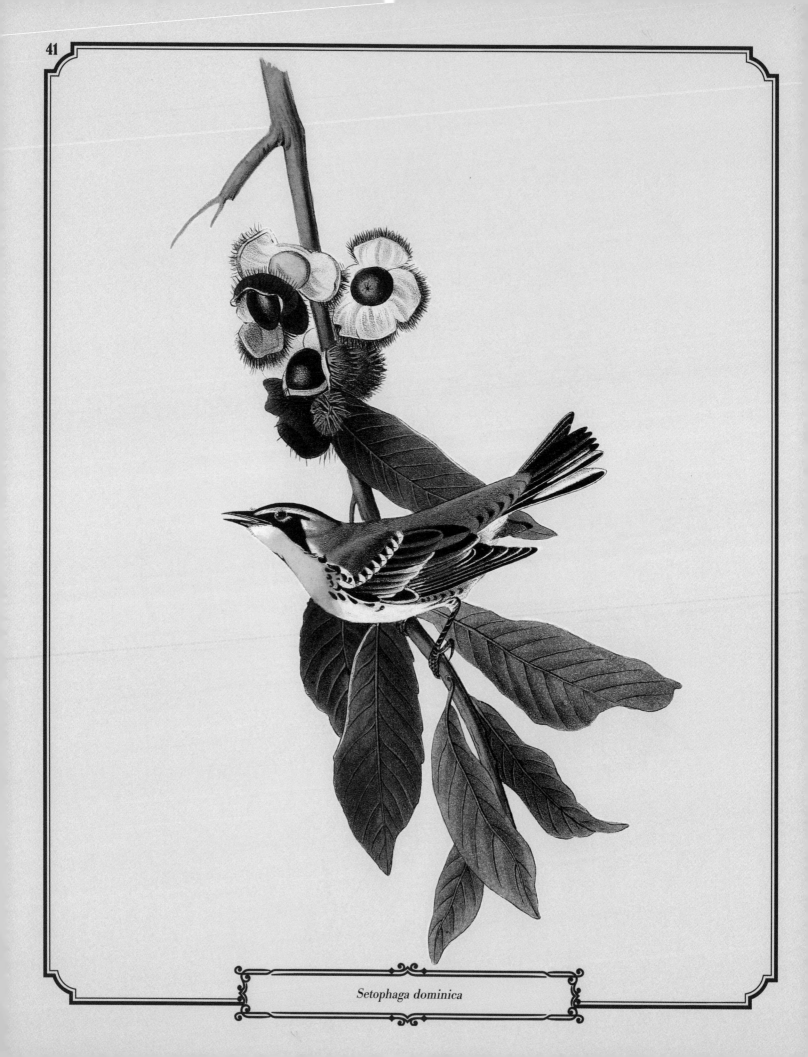

Setophaga dominica

Yellow-throated warbler

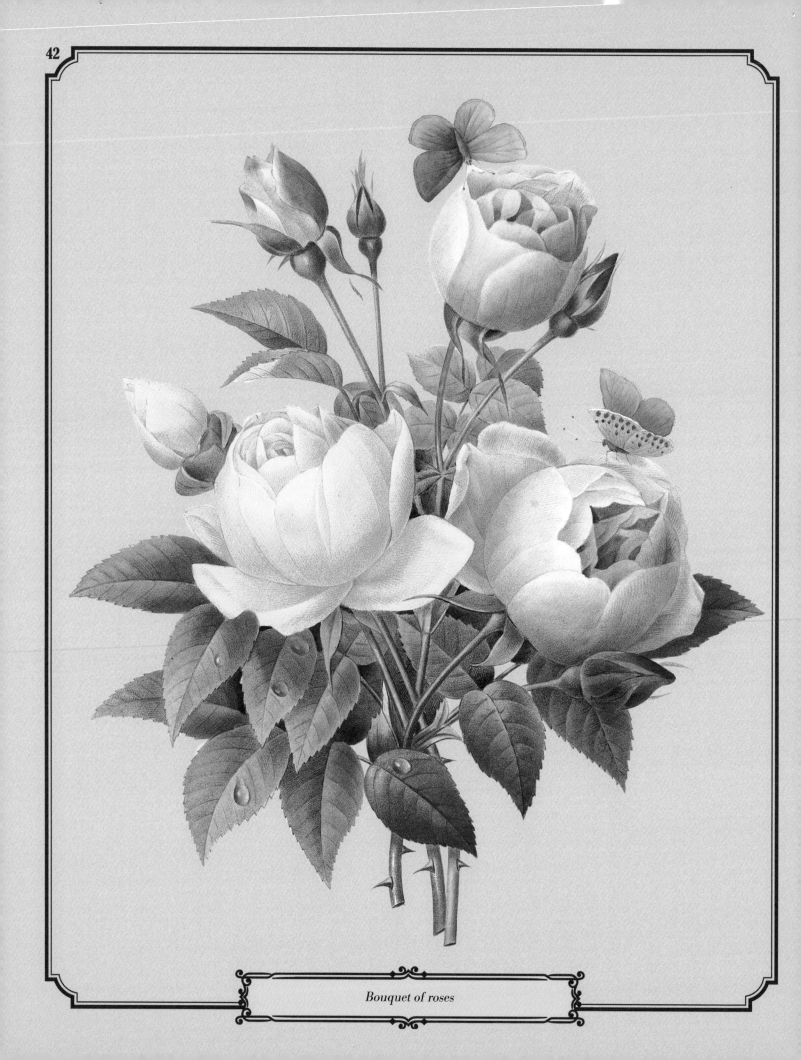

Bouquet of roses

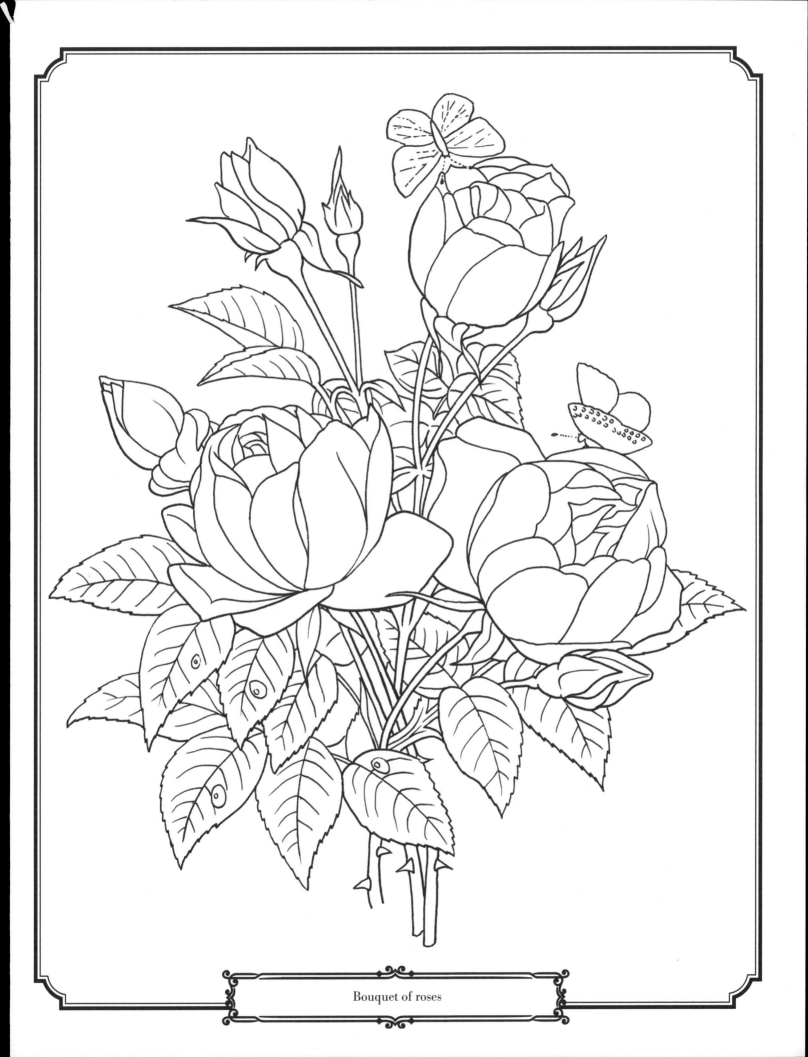

Bouquet of roses

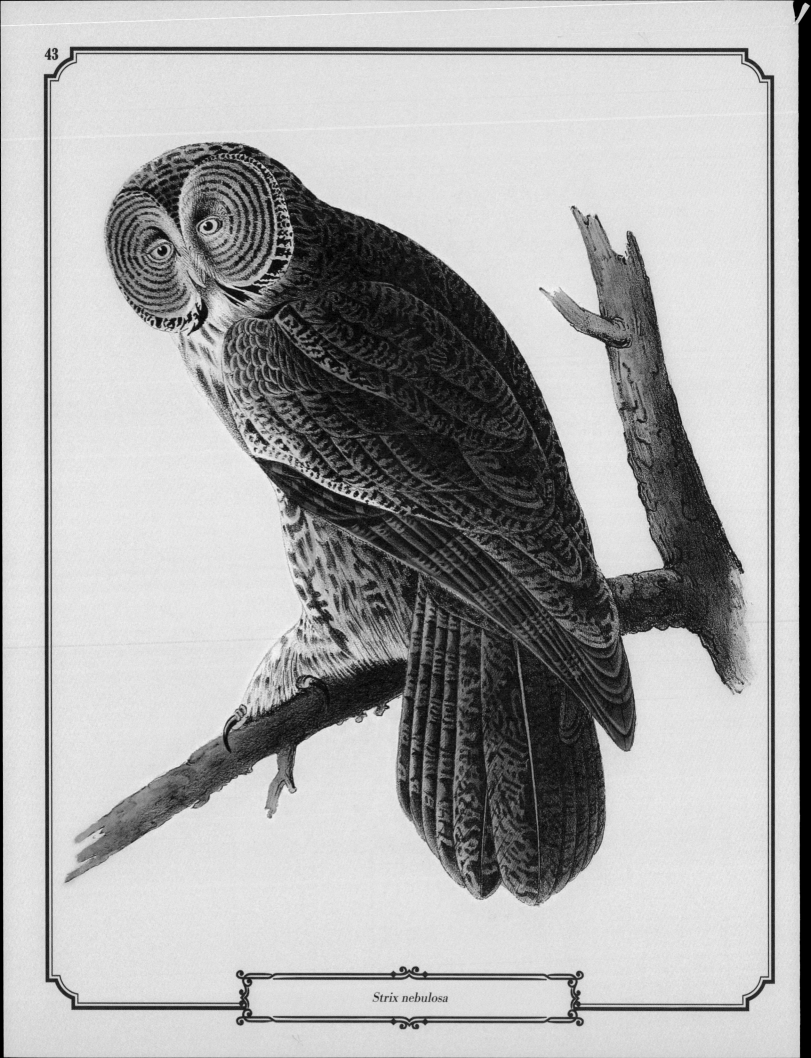

Strix nebulosa

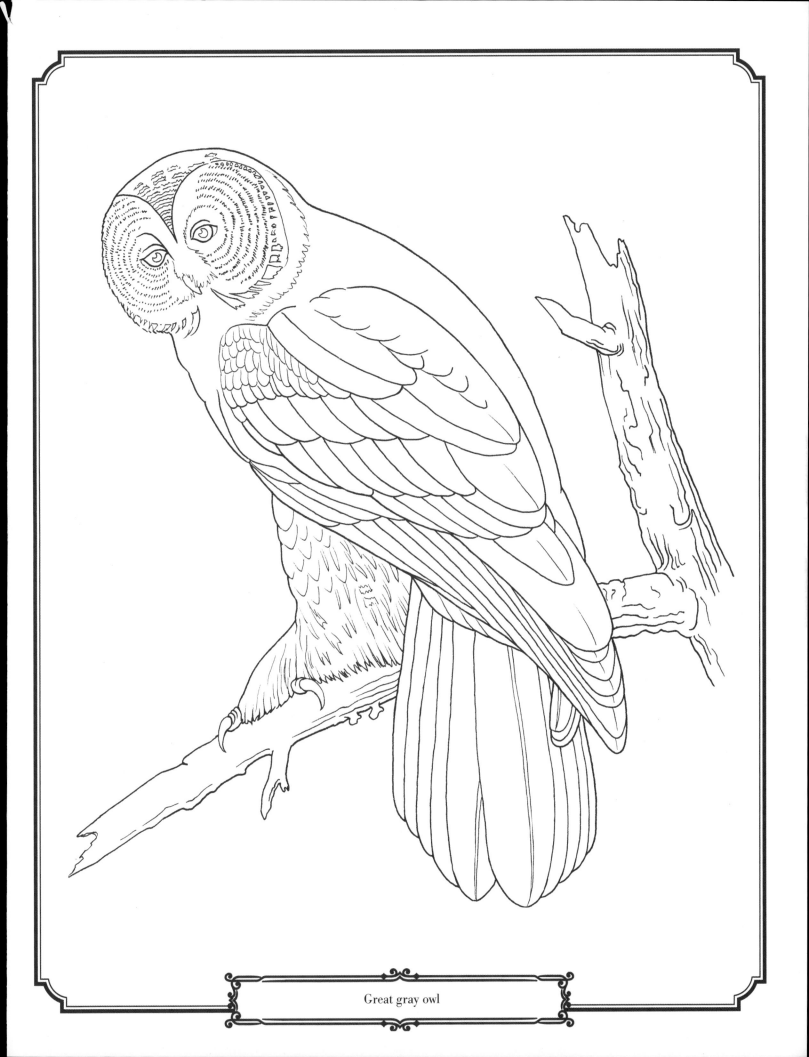

Great gray owl

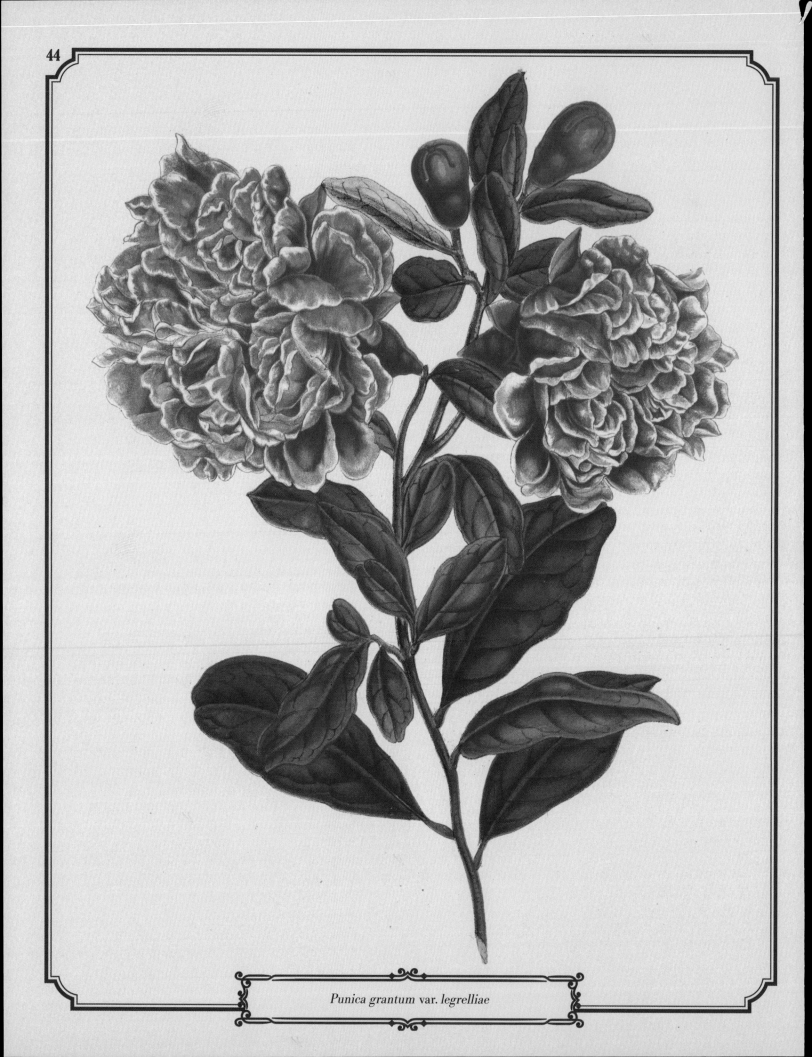

Punica grantum var. legrelliae

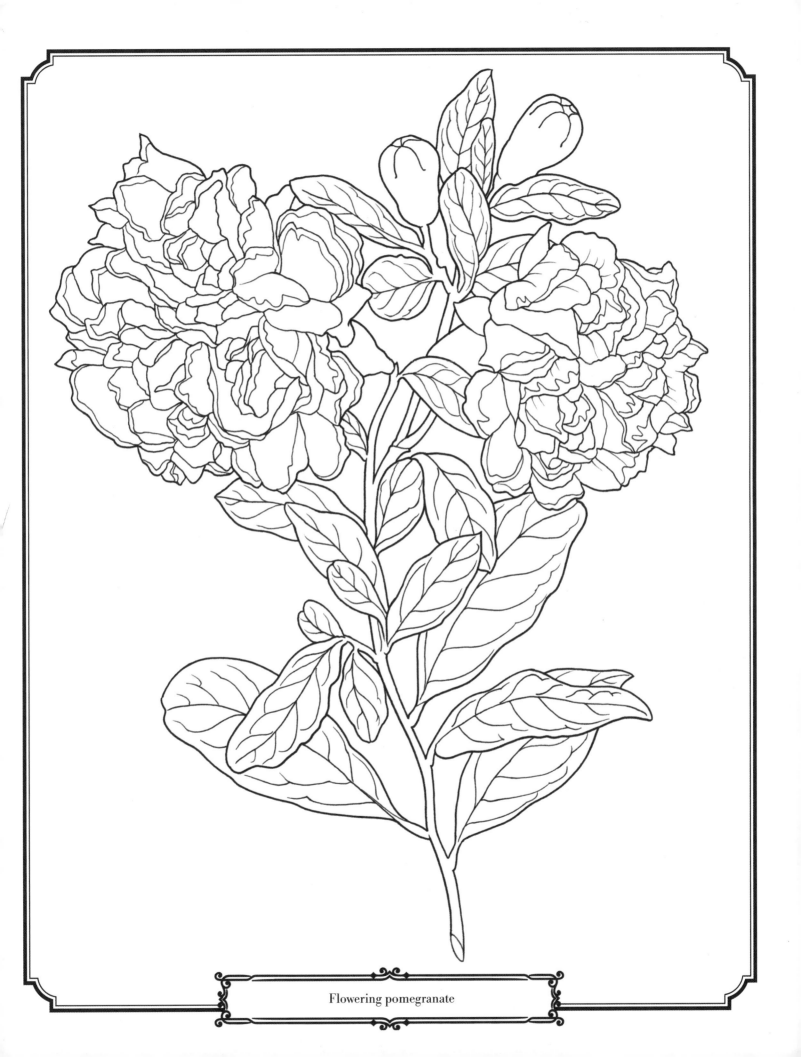

Flowering pomegranate